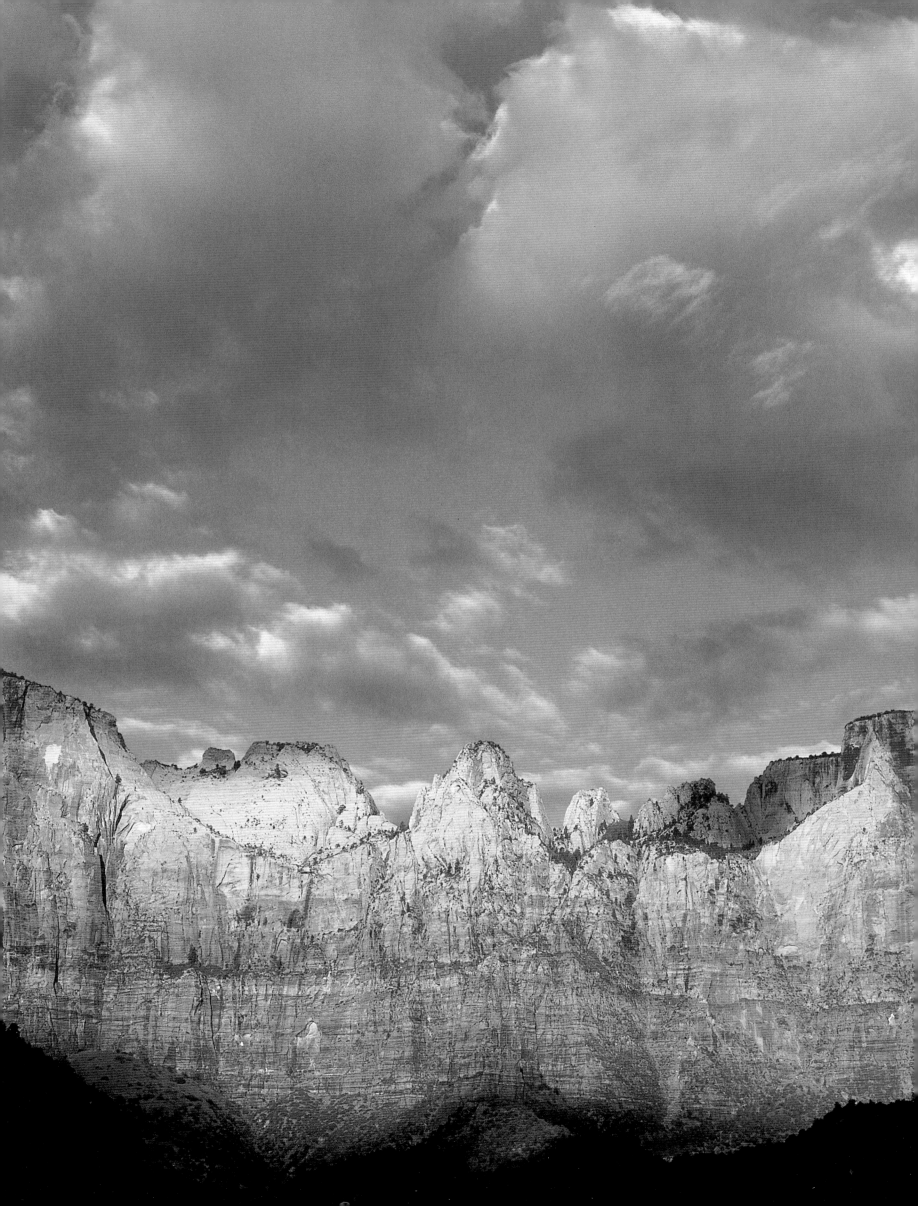

ZION
NATIONAL PARK

SANCTUARY
IN THE DESERT

BY

NICKY LEACH

SIERRA PRESS
MARIPOSA, CA

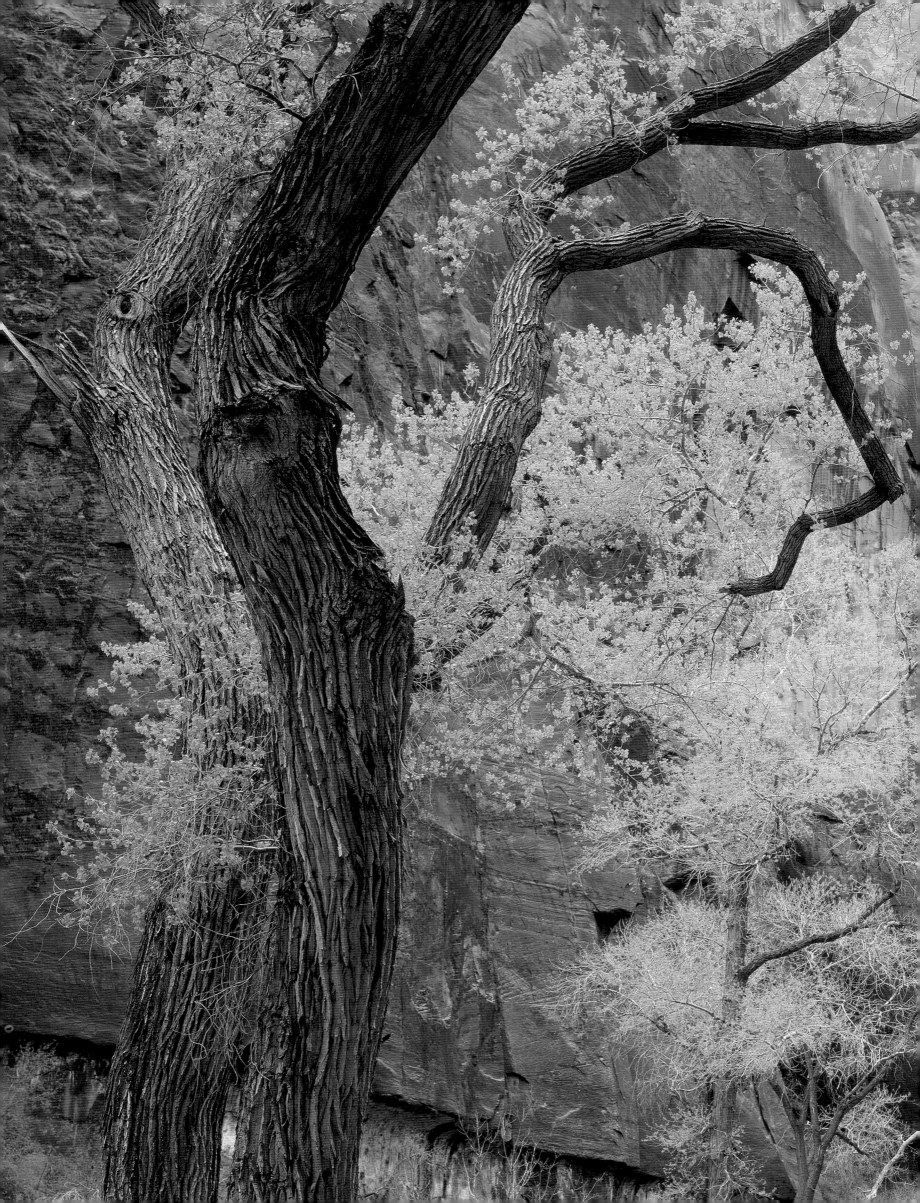

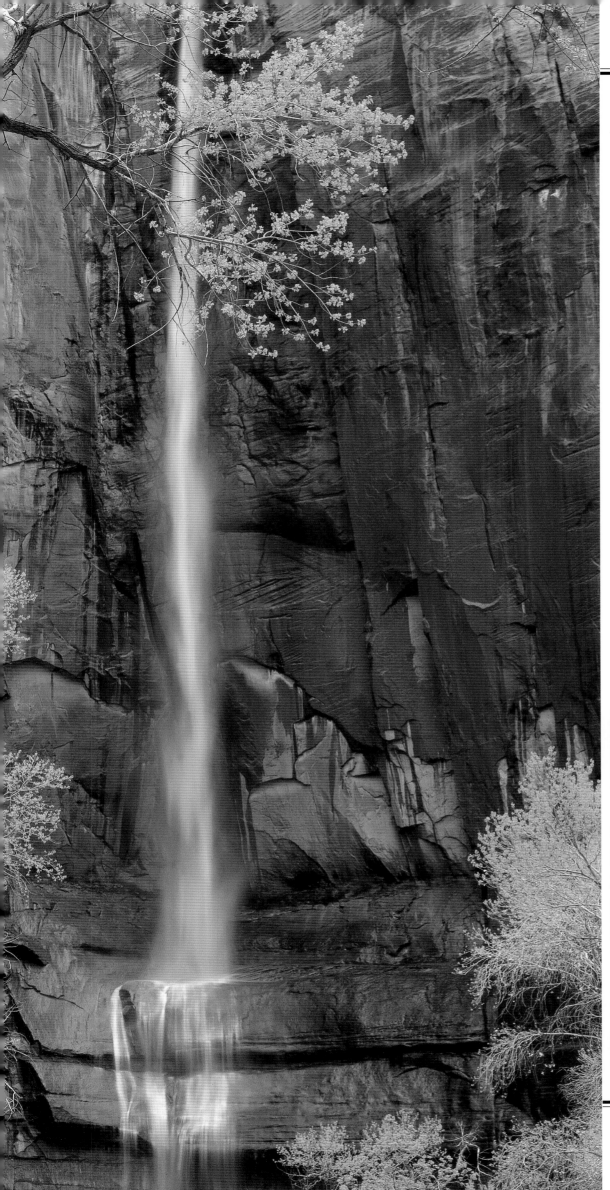

CONTENTS

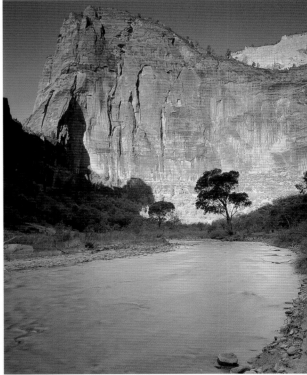

DEDICATION:

To my parents, Paul and Zena Leach, who never left but understood when I did—NL

ACKNOWLEDGMENTS:

Thanks to Jeff Nicholas and Sierra Press for asking me to write about my favorite subject; editor Cindy Bohn for another great blue-pencil job; Denny Davies, Tom Haraden, and the staff of Zion National Park for taking time to talk with me, check facts, and make suggestions; and finally, to Mary Lawrence, a fine travel companion and constant friend.

FRONT COVER:
Angels Landing and cottonwoods.
PHOTO © SCOTT T. SMITH
INSIDE FRONT COVER:
Cliffs above Clear Creek, sunrise.
PHOTO © LAURENCE PARENT
TITLE PAGE:
Towers of the Virgin, early morning.
PHOTO © RUSS BISHOP
PAGE 4/5:
Ephemeral waterfall and cottonwood in the Temple of Sinawava. PHOTO © CHARLES CRAMER
PAGE 5:
Angels Landing and the Virgin River.
PHOTO © JC LEACOCK
PAGE 6 (BELOW):
Bigtooth maple on frozen surface of Clear Creek.
PHOTO © GEORGE WARD
PAGE 6/7:
Towers of the Virgin, winter morning.
PHOTO © TOM TILL

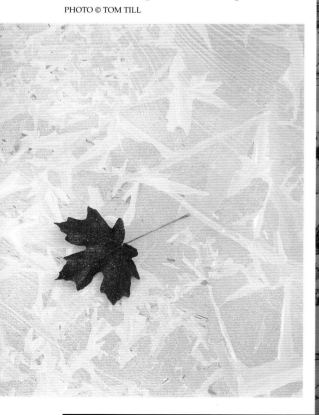

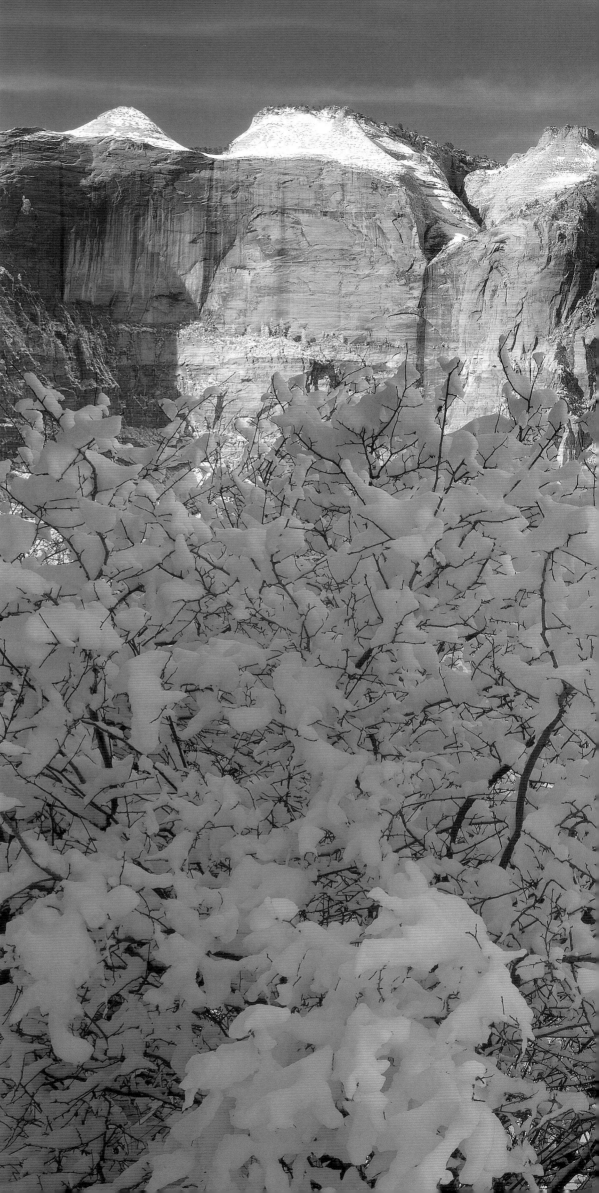

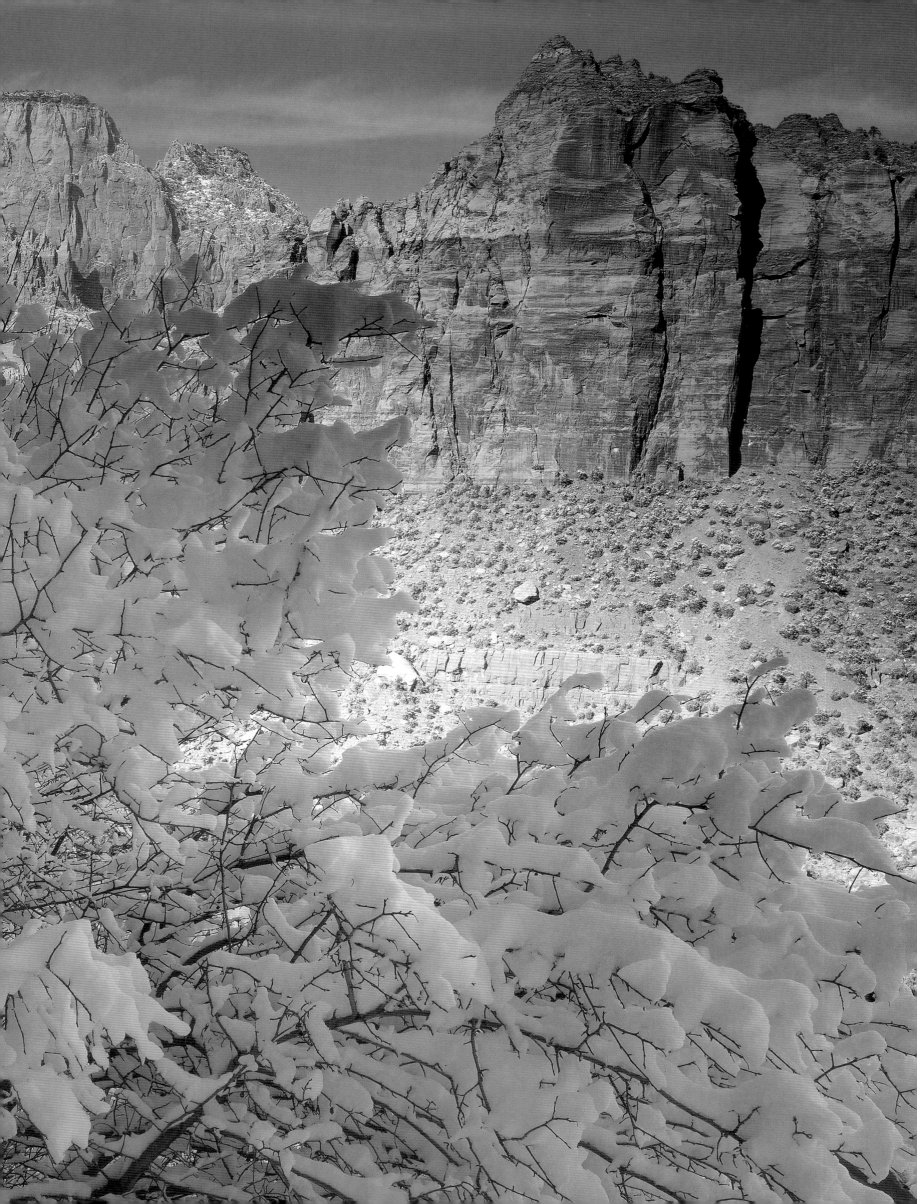

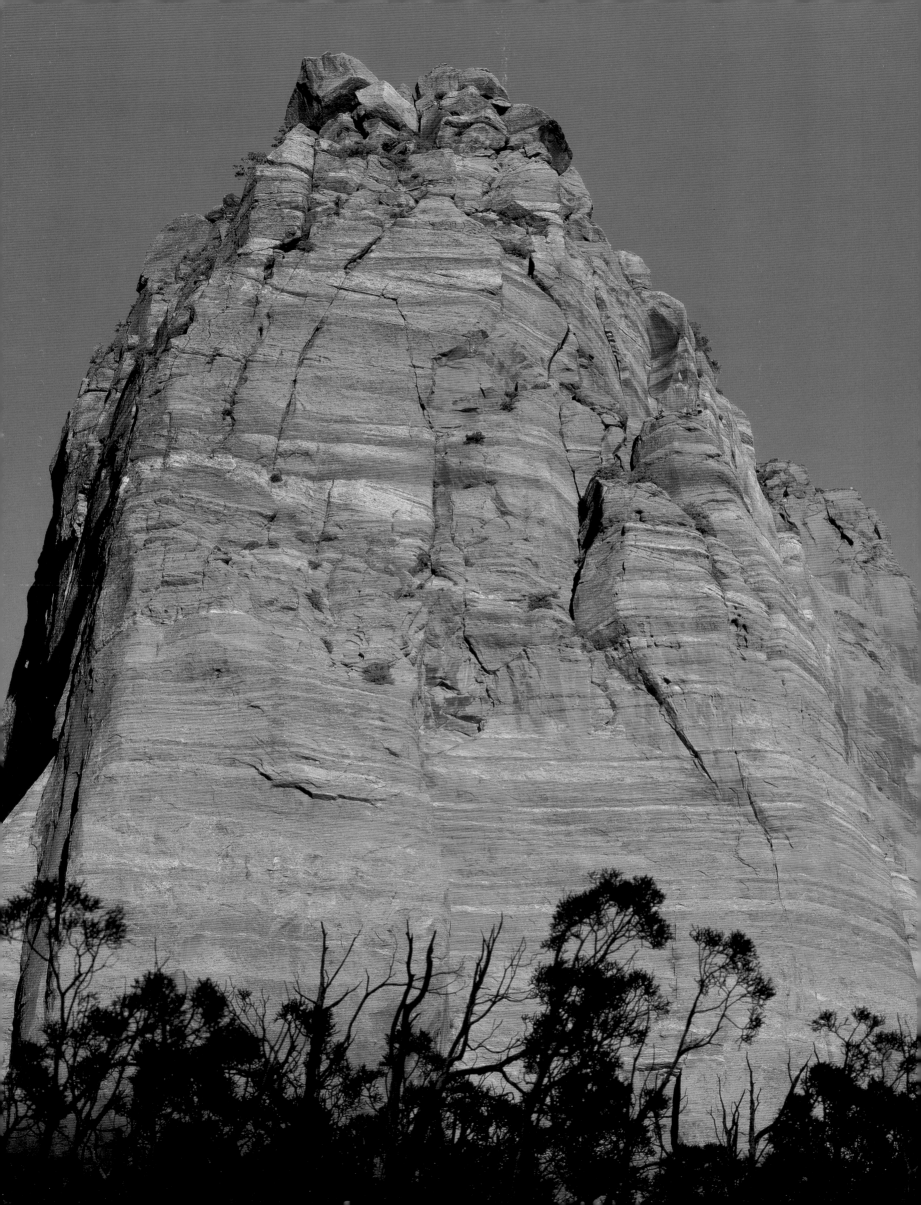

ZION INTRODUCTION:

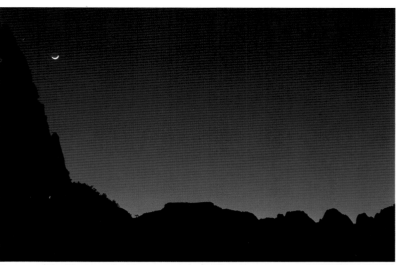

Towers of the Virgin and setting moon, dusk, Zion Canyon. PHOTO © PAT O'HARA

It is one of those clarion spring mornings in Zion that comes close to earthly perfection. A red mackerel dawn sky has limned Renaissance blue in the full light of day. A whisper of a breeze ruffles the new-leafed cottonwoods along the Virgin River and sets the tall ponderosa pines creaking in their moorings in crevices high in the cliffs. Two red-tailed hawks circle lazily on the thermals, then drop out of sight into a huge, desert-varnished window-blind arch in the pale sandstone canyon wall. Mule deer—the soft rustlers at the tent door in the predawn gloom—jump daintily away on ballerina legs then dart to deeper cover, safe from human eyes and the hungry gaze of the mountain lion.

Above the valley, the domes, spires, and temples of Zion seem to raise great angular heads to the heavens, their time-worn, craggy faces streaked and etched by falling water and year-in, year-out exposure to the weather. "There is an eloquence to their forms which stirs the imagination with a singular power and kindles in the mind," wrote geologist Clarence Dutton in 1880. "Nothing can exceed the wondrous beauty of Zion . . . in the nobility and beauty of the sculptures there is no comparison."

Although it gets all the press, Zion Canyon is just a fraction of a park that might better be described as a giant outdoor museum, preserving some of the world's most extraordinary geological, archeological, and natural resources. The heart and soul of Zion, though, is the Virgin River, whose North Fork rises to the northeast near Cedar Breaks. The river eats its way through the southern Markagunt Plateau, then confluences with the East Fork in Zion Canyon downstream from Parunuweap Canyon. From here, it continues down to Hurricane and out of Utah via the Virgin River Gorge, joining the Colorado River in Lake Mead for the last leg to the Gulf of California. The Southern Paiute call it Parus ("whirling water"), but its European name was given in 1776 by the Spanish Dominguez-Escalante Expedition, priests who understood first-hand the miracle of water in the desert.

After a week exploring Canyon Country's vast spaces, my friend Mary plumped herself down beside the Virgin River, plunged her toes into the water, and sighed happily. "It's so cozy here," she said. "I feel safe within these high walls." I know what she means. Zion was the first park I ever saw 20 years ago, and it spoiled me for all others. Nowhere else fills the senses so completely and begs frequent return visits.

The early morning is comfortably cool as I set out from camp along the 2-mile Parus Trail, idling among sagebrush, cactus, and grasses that once provided good grazing for the cattle of pioneer Mormon ranchers. Tits kafuffle and flap in the shrubs, and a pair of dippers breasts the river current on spindly but strong legs, looking for insects among the riffles. I hear a tinkling waterfall of down-lilting notes echo across the canyon, bouncing from boulder to boulder. Ah, the canyon wren! Now I know I'm home.

The trail passes under the highway bridge, and I walk up onto the deserted scenic drive. The canyon narrows noticeably here and the tops of the 7,000-foot formations are lost to view. The Temples of the Virgin, the Beehives, the Sentinel, the Three Patriarchs, the Great White Throne, the Temple of Sinawava. Their names are unforgettable, etched on the memory like lifetime honorees in Zion's Geological Hall of Fame. Thank an enthusiastic Methodist minister who visited Zion in 1916 for such colorful monikers. Today, naming rock-climbing routes is the new name game in Zion. But the heavenly theme hasn't disappeared. Anyone for Space Shot today?

Although only a tiny fraction of Utah is contained within the park, 85 percent of the state's flora and fauna species are found here, including 800 plant species, 289 bird species, and 75 mammal species. This can partly be explained by the park's 4,000- to 9,000-foot elevation span, which takes in low-desert scrub, mid-elevation chaparral, and subalpine evergreen forests. But there could never be so much life without the presence of water—and this, Zion has in spades. From the year-round flows of the Virgin River to the seeping sandstone cliffs of the canyon narrows, a remarkable number of living things set up shop and thrive. Some, like the pearl-sized Zion snail of the Zion Narrows, live nowhere else.

The mouth of the Narrows is my final destination today. Here the swollen river bursts out of its long, narrow, confined passage

OPPOSITE: Tucupit Point at sunset, Kolob Canyons. PHOTO © SCOTT T. SMITH

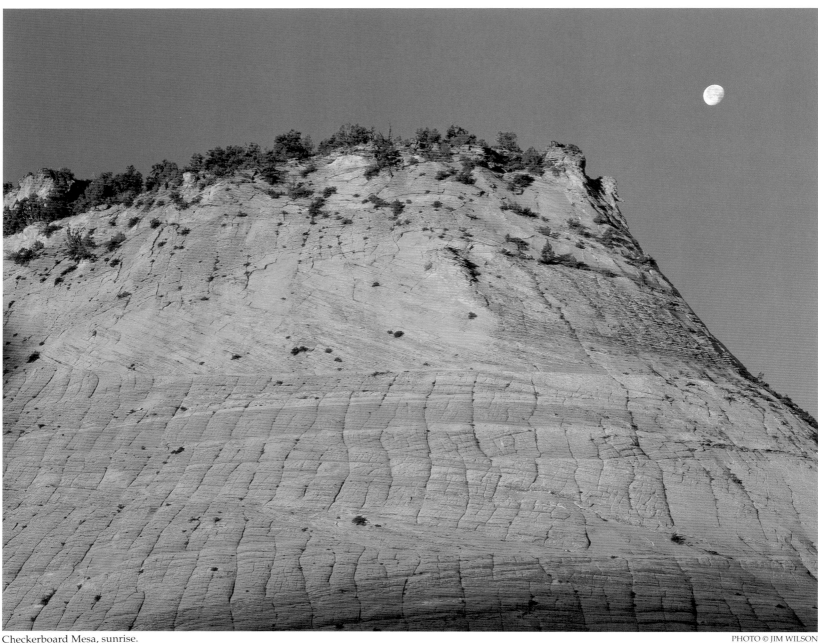

Checkerboard Mesa, sunrise.

into the canyon, in a wet, hissing, slurping, soupy mess of sediment-laden waters that tumble over boulders and continue the river's relentless cycle of deposition and downcutting through 260 million years of sedimentary rocks. It's estimated that the Virgin can continue cutting as much as 1,000 feet deeper into its course and maintain its present gradient. Eventually, though, it will consume the whole plateau, reducing it to a flat, gentle plain. All good things come to an end.

That one little river can achieve so much is remarkable. But with water covering 75 percent of the planet, the odds are definitely in its favor. In a desert where aridity is the defining characteristic, it is the role of water that lingers longest in the memory in Zion. The great anthropologist and writer Loren Eiseley once said: "If there is magic in this world, it is contained in water." I ask the river: Is this true? Yes, says the river. Yes. Just take a look around.

Orderville Canyon, tributary of the Virgin River, The Narrows.

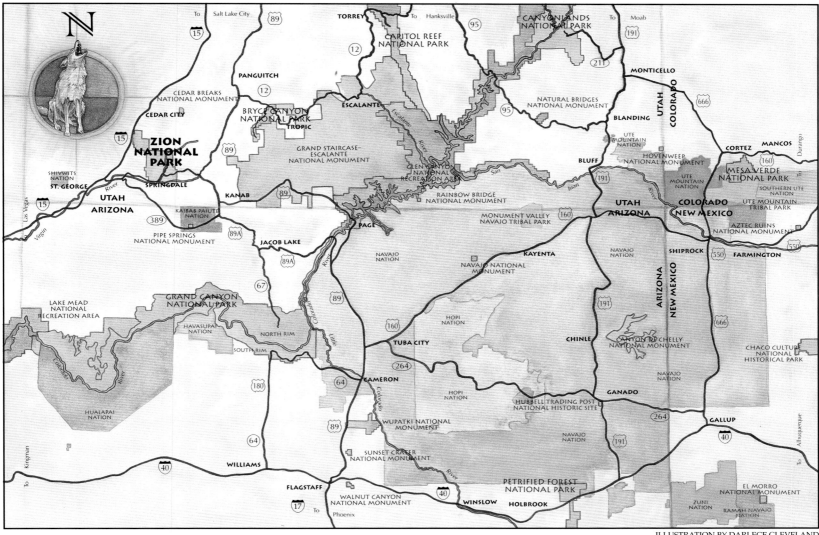

ILLUSTRATION BY DARLECE CLEVELAND

For travelers arriving from the West, via Interstate 15, Zion National Park is just the first in a tight cluster of remarkable preserved natural and cultural treasures clustered on the road map. Dubbed the Southwest's Grand Circle, within a 250-mile radius of Zion are 12 national parks, 14 national monuments, seven tribal parks, seven state parks, six national forests, and 17 wilderness areas. Nearly all are reachable by paved, all-weather highways that encircle the Four Corners states of New Mexico, Arizona, Colorado, and Utah. A word of caution: most vacationers try to do as much of the Grand Circle as they can and end up rushed and suffering from sensory overload, as sight after awe-inspiring sight streaks past the car window. To avoid that "industrial tourist" feeling, visit two or three parks and allow time to stop and smell the sagebrush along the way. Don't worry; you'll be back.

The Grand Circle sits inside a 130,000-square-mile physiographic province known as the Colorado Plateau, a mile-high sedimentary uplift split by faults and carved by water into a series of spectacular tablelands, vertiginous canyons, and wierd rock formations. Southern Utah's Canyon Country arrived on the scene comparatively late, when 15 million years ago, local faults pushed up a series of plateaus, from the Grand Canyon to Bryce Canyon into a geological "Grand Staircase" of color-coded cliff steps. To the south are the Coconino and Kaibab Plateaus, on either side of the Grand Canyon; to the east the Paria, Kaiparowits, and Paunsaugunt Plateaus, the mother rocks for Bryce Canyon and Grand Staircase–Escalante National Monument. To the northeast is the 11,000-foot Aquarius Plateau, the highest plateau in America, flanked by Boulder Mountain, one of several, now-extinct volcanoes atop the plateaus. Zion nestles in the southern section of the Markagunt Plateau. Both the Markagunt and Colorado Plateaus drop away on the western edge of Canyon Country into the Great Basin Desert, a miragelike low desert of shimmering basins and ranges extending to Nevada and California.

Canyon Country's rough-and-tumble geology has left a unique legacy in the landscape. Within a couple of hours of Zion, soft paintbox-hued high-country hoodoo, lush green forests, and wildflower-strewn meadows hug cliffsides at Cedar Breaks National Monument and Bryce Canyon National Park. Great dizzying sweeps of angled, eroded cliffs and intimate canyons reach to the horizon in Grand Canyon, Canyonlands, and Arches National Parks and Grand Staircase–Escalante National Monument. Ancient and modern cultures touch at Pipe Spring National Monument, Edge of the Cedars State Park, Monument Valley Navajo Tribal Park, Wupatki National Monument, and numerous other archeological sites whose stories of survival and loss help us to bear witness to our own.

PAGE 12/13: Pinyon pine and Mount Kinesava, Huber Wash. PHOTO © JOHN DITTLI

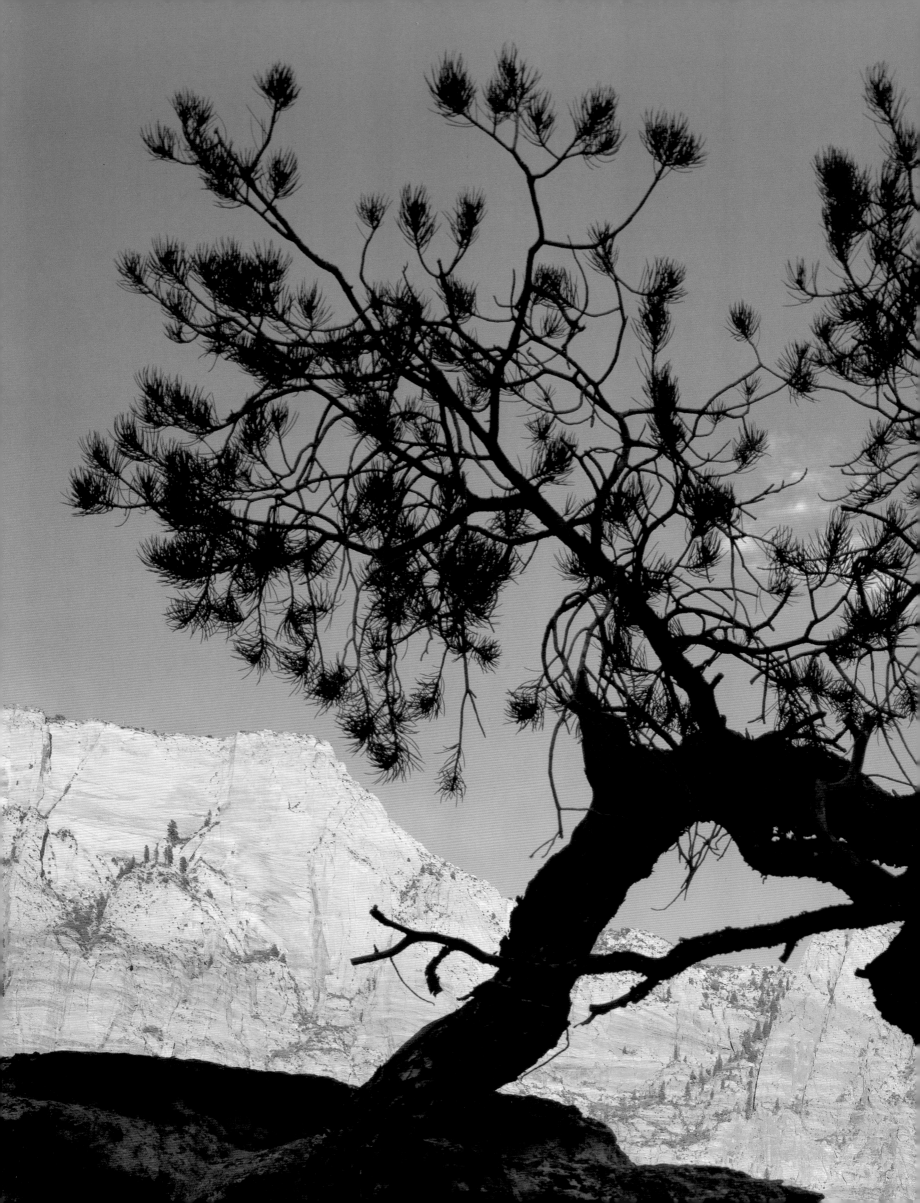

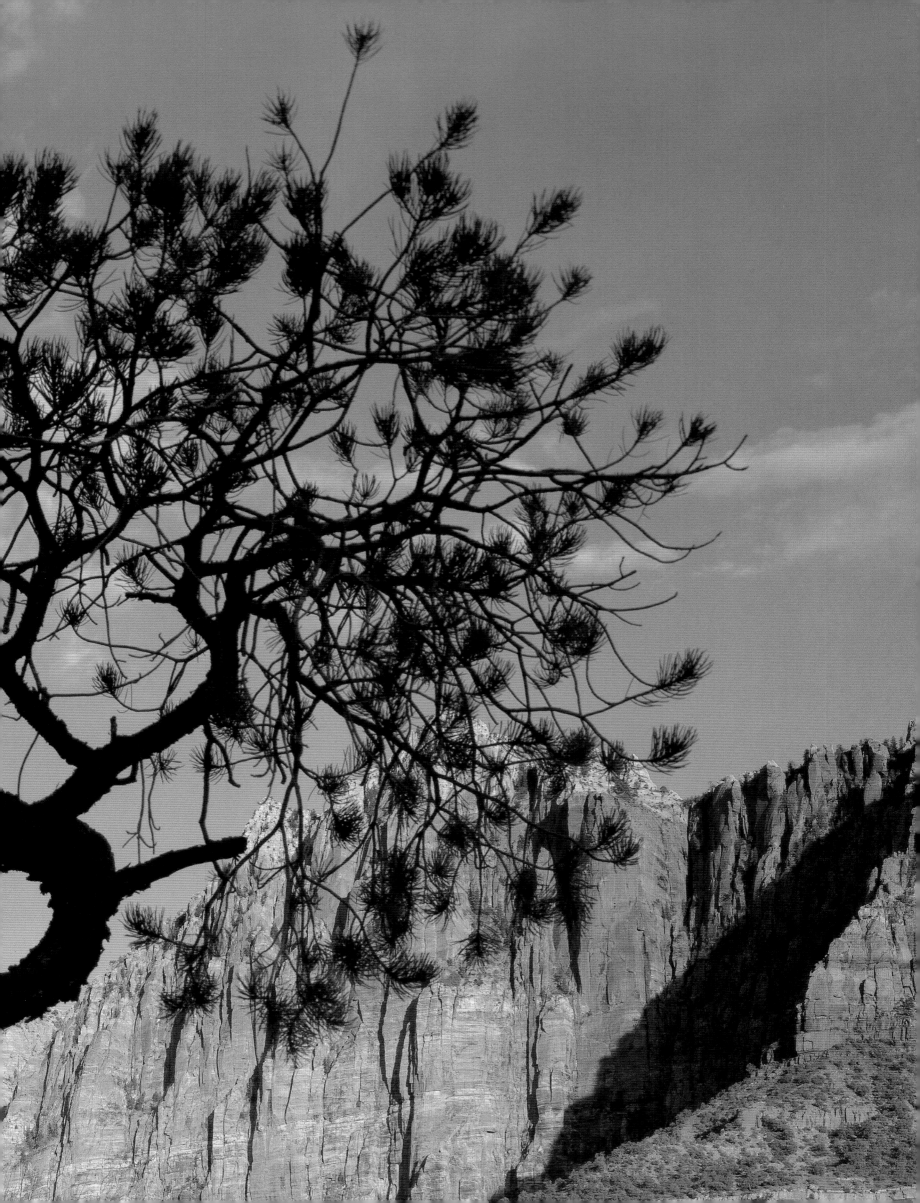

ZION NATIONAL PARK

Zion National Park sweeps across 229 square miles of southwestern Utah's Markagunt Plateau—a richly varied landscape of high, forested plateaus, deep, narrow desert canyons, and dramatically eroded rock towers and mesas. The centerpiece of the park is Zion Canyon, where the North Fork of the Virgin River and its tributaries have jigged out a spectacular gorge through salmon-hued sandstone, with canyon walls rising 2,000-3,000 feet above the scrubby desert floor. But 94 percent of the park remains designated wilderness, the province of cougars and Mexican spotted owls. Expect nothing but the companionship of nature on backcountry trails in the high country of the Kolob Terrace in the park's central section, beneath the sentry formations of the Kolob Canyons in northwestern Zion, and among the quiet slickrock canyons and mesas of the East Rim.

A paved, all-weather road, State Highway 9, traverses the park and links Interstate 15 with US Highway 89, via the 1.1-mile Zion-Mt. Carmel Tunnel (drivers of RVs and other large vehicles should call the park ahead of time to check on size and use restrictions in the tunnel). Fees are collected at either the East Entrance or South Entrance, where rangers hand out the park Map and Guide and brochure. Most visitors arrive via the South Entrance, on the park's west side, passing through the pretty little gateway community of Springdale, the busy nexus of lodging, restaurant, gas, and other visitor services for the park. Book well ahead for lodgings in and around Zion. Within the park, only Zion Lodge offers food and lodging but its popularity means that it is fre-

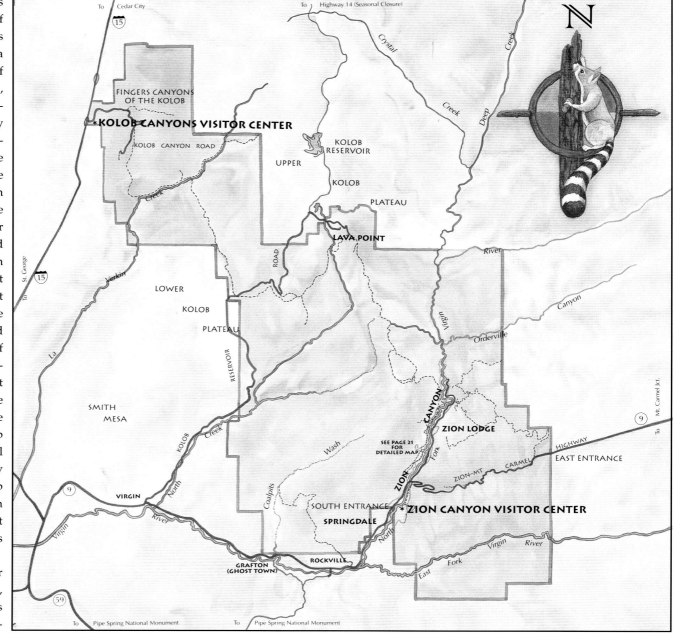

ILLUSTRATION BY DARLECE CLEVELAND

quently booked up to a year ahead. Scattered visitor services are available on the east side of the park, between the eastern boundary and Mt. Carmel Junction, with full services available in Kanab.

Just inside the South Entrance is Zion Canyon Visitor Center, open year round (with slightly shorter hours in winter), and adjoining the large Watchman and South Campgrounds. Park here to view indoor and outdoor exhibits on Zion; plan hikes, scenic drives, and other activities with National Park Service rangers; attend an interpretive talk; and board the free Zion Canyon Shuttle to reach trailheads along 6-mile Zion Canyon (see Getting Around

Zion). A bookstore, run by Zion Natural History Association, one of the oldest nonprofit cooperating associations in the park system, offers a complete selection of park books, maps, posters, and other publications on the area, with proceeds benefiting the park. Visitor services are also available at the smaller Kolob Canyons Visitor Center (fee collected), off Interstate 15, next to the 5-mile Kolob Canyons Scenic Drive.

OPPOSITE: Sacred datura blooms in Court of the Patriarchs. PHOTO © TOM TILL

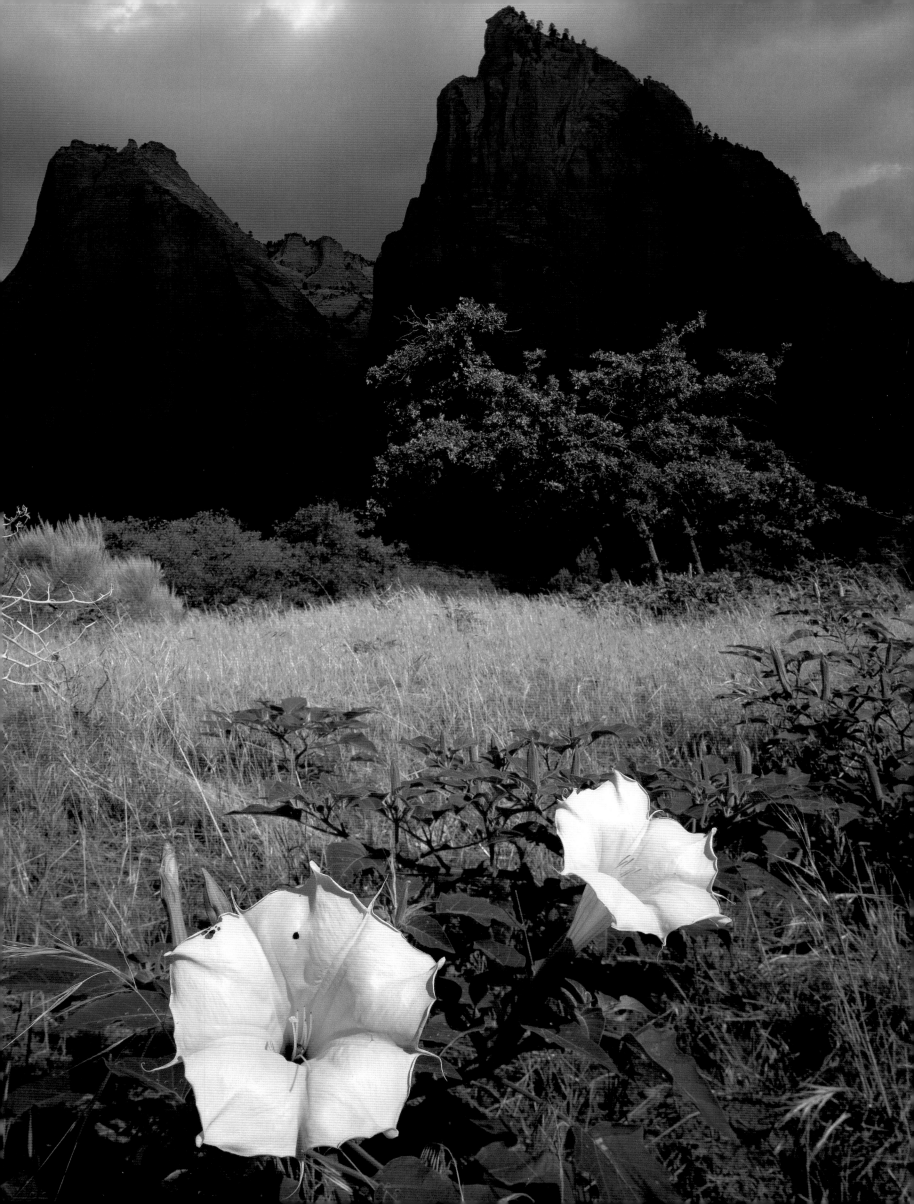

GEOLOGY

Zion National Park was set aside for the distinctive beauty of its geology and to showcase the many remarkable ways stone has been sculpted by water. But this is no mere outdoor museum of rocks, a finished masterpiece; think of it more as a performance piece, changing aspect constantly, reacting to forces all around it. Earthquakes shudder through the rocky depths, gravity pulls down another rock, and water allows life to flourish, then rearranges it during powerful flashfloods. Zion is Nature's work in progress.

Converging branches of the small but tuneful Rio Virgin and La Verkin and Taylor Creeks in Kolob Canyons—all born in the high country to the north—are the master sculptors of Zion's parent rock, the Markagunt Plateau. Directly north of Zion Canyon, the North Fork of the Virgin River has worn a groove, barely 35 feet wide in places, through the 2,000-foot-high pink and white Navajo Sandstone walls, to form the famous Zion Narrows.

The abrasive, sediment-laden waters of the river and its tributaries scrape constantly at the jointed Navajo Sandstone cliffs, undermining the precipitous walls, until huge slabs of rock shear away, like onion layers peeling from the bulb. In this manner, the great rocks maintain their verticality, despite persistent undercutting. West of the Kolob Terrace, creeks have incised deep sandy drainages and left bare rock to the mercy of the elements. Persistent erosion fashioned the unusual east-west–trending headlands of Kolob's Finger Canyons and the 310-foot span of Kolob Arch. The sculpting power of water is particularly evident along the fresh break at this far western edge of the Markagunt Plateau, where the vermilion-hued Finger Canyons tower over their surroundings like sentries guarding a secret palace.

The sheer sandstone faces are cracked, crumbled, smoothed, and polished by falling water, snow, ice, wind, rain, plants, and animals into the landmarks for which Zion is famous: the Altar of Sacrifice, Angels Landing, the Temple of Sinawava, Cable Mountain, the Three Patriarchs, the Watchman, the Great White Throne, and many more. The faces of these great temples range from pale and smooth to streaked, blackened, or bruised purple, brown, and pink, their high coloration caused by the weathering of iron-rich sandstone, minuscule bacteria living on porous sandstone surfaces, and iron-bleeding caprocks on bald summits.

The journey to the park's South Entrance from the Hurricane Cliffs on the west allows you to "read" the rocks. Nine different strata are found in Zion. Its basement rocks began to take shape roughly 260 million years ago in the enormous, shallow Permian Ocean, which covered the western margin of the supercontinent of Pangaea before it split apart into the continents. Fossiliferous Kaibab Limestone in the Hurricane Cliffs at the entrance to Kolob Canyons dates from this era of tropical climate and primitive marine creatures. As the climate dried, a delta was born, where stream sediments mixed with limy marine deposits and eventually hardened into the soft, colorful bands of the Moenkopi Formation. The Moenkopi seems to blend with the overlying, multicolored layers of gravel, sand, volcanic ash, and petrified wood of the crumbling Chinle Formation rocks in the Virgin River Valley. Uranium is plentiful in the mineral-laden Chinle. It attracted mid-20th-century prospectors, who descended in droves to extract the ore for government stockpiles. Another indicator of the presence of uranium is wandlike prince's plume and milkvetch, which thrive on the selenium often found in proximity to uranium.

As the continents began to drift apart and the climate changed again, lakes filled depressions and streams cut shallow pathways across the evolving landscape. Freshwater deposits were compressed into the colorful tinted rocks of the Moenave and Kayenta Formations, which form compact ledges in the main park. Dinosaurs dominated the earth during this period, their tracks in the ruddy Kayenta Formation a vivid reminder of the time when flesh-and-blood giants, not stone monoliths, ruled the land.

The Zion we know today came into existence roughly 175 million years ago, when increasing heat and aridity led to the formation of an enormous, Sahara-like desert of blowing sand covering some 150,000 square miles of the West. Under such conditions, most life withered, and the landscape was dominated by a series of cross-bedded dunes up to 3,000 feet high, which eventually hardened into Zion's characteristic Navajo Sandstone. Cross-bedding in the formation is particularly obvious on the eastern side of the park, where the changing direction of Jurassic winds and the later action of rainwater percolating down joints in the rock are preserved in the cross-hatched surface of hulking monoliths like Checkerboard Mesa. The

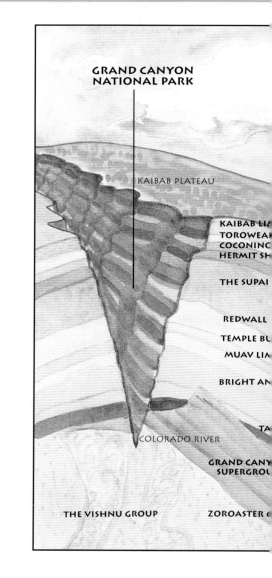

fine-grained Navajo Sandstone reaches its greatest thickness in Zion Canyon's 2,400-foot-deep Temple of Sinawava, making it a great place to view this champion cliff-former.

The marine sediments in the Temple Cap and Carmel Formations that top some of Zion's best-known landmarks speak of another round of seas that reclaimed the desert a few million years later. The Temple Cap is very red from the quantity of iron in the formation, and it is this that bled down into the Navajo rock below to cause such brilliant coloration in the formation. Weathering has also caused red streaks to mark the faces of higher cliffs such as the Altar of Sacrifice and the West Temple behind the new human history museum. The youngest rocks are the Cretaceous Dakota Formation, only found atop 8,766-foot Horse Ranch Mountain in the remote Kolob Canyons, and the midnight-hued basalts, barely several million

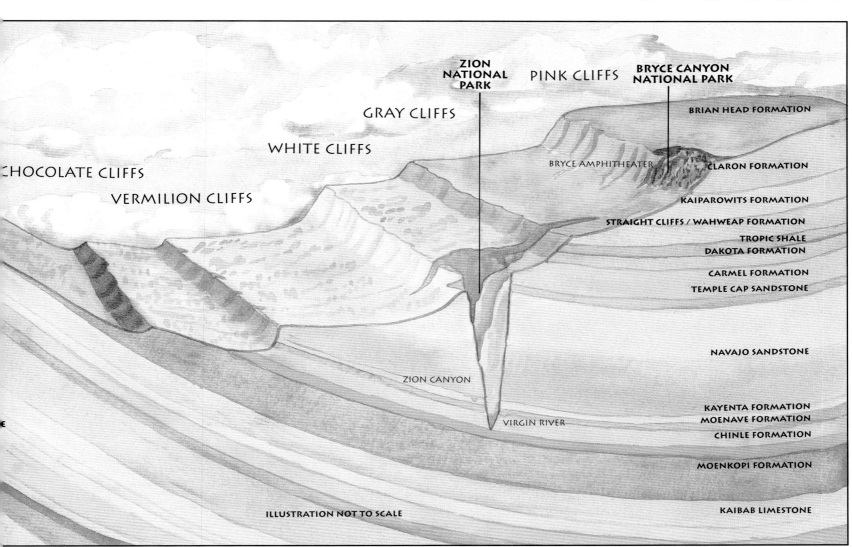

ZION NATIONAL PARK
PINK CLIFFS
BRYCE CANYON NATIONAL PARK
GRAY CLIFFS
WHITE CLIFFS
CHOCOLATE CLIFFS
VERMILION CLIFFS
BRIAN HEAD FORMATION
BRYCE AMPHITHEATER
CLARON FORMATION
KAIPAROWITS FORMATION
STRAIGHT CLIFFS / WAHWEAP FORMATION
TROPIC SHALE
DAKOTA FORMATION
CARMEL FORMATION
TEMPLE CAP SANDSTONE
NAVAJO SANDSTONE
ZION CANYON
KAYENTA FORMATION
MOENAVE FORMATION
CHINLE FORMATION
VIRGIN RIVER
MOENKOPI FORMATION
ILLUSTRATION NOT TO SCALE
KAIBAB LIMESTONE

ILLUSTRATION BY DARLECE CLEVELAND

years old, that darken the surface of the Kolob Terrace.

The laying down of Zion's sedimentary deposits was mostly complete by about 65 million years ago. It has been left to ongoing movement along faults and erosion to shape the land into the characteristic canyon-and-mesa topography associated with Canyon Country today. The Colorado Plateau began to be pushed up during the early Cenozoic Era, at about the same time as the dinosaurs disappeared. A series of deep-seated parallel local faults runs through this section of the Colorado Plateau. The biggest of these is the Hurricane Fault, which runs along the western edge of the Markagunt (and Colorado) Plateau. Ancient movements along this fault line created the contorted Kanarra Fold in the Kolob Canyons, long before the Colorado Plateau was squeezed up.

The high plateaus that seem to float across southern Utah came into existence much later, roughly 15 million years ago, when the release of pressure along faults caused the Markagunt, Paunsaugunt, Kaibab, Kaiparowits, Paria, and Aquarius Plateaus to break away and rise even higher on the parent Colorado Plateau. These soaring tablelands have remained distinct entities ever since, their shapes continually reworked by natural sculpting into the steps of a colorful geological "Grand Staircase," which marches northward from the Grand Canyon through Zion to Bryce Canyon. The individual formations form a color-coded sequence, best seen all at once from the LeFevre Overlook on the north side of the Kaibab Plateau, not far from the North Rim of the Grand Canyon. They are, in order: the Chocolate Cliffs (Moenkopi Formation), Vermilion Cliffs (Moenave and Kayenta Formation), White Cliffs (Navajo Sandstone), Gray Cliffs (Kaiparowits Formation), and Pink Cliffs (Claron Formation).

Earthquakes still rumble along this southernmost extension of the active Wasatch Fault (second only to California's San Andreas Fault in potential destructiveness). Seismic activity causes hillside slumps, like the one that occurred outside the town of Springdale in September 1992. Such incidents remind us that we are standing on a young and restless land and that we must sometimes accept our powerlessness in order to enjoy the greater gifts life brings.

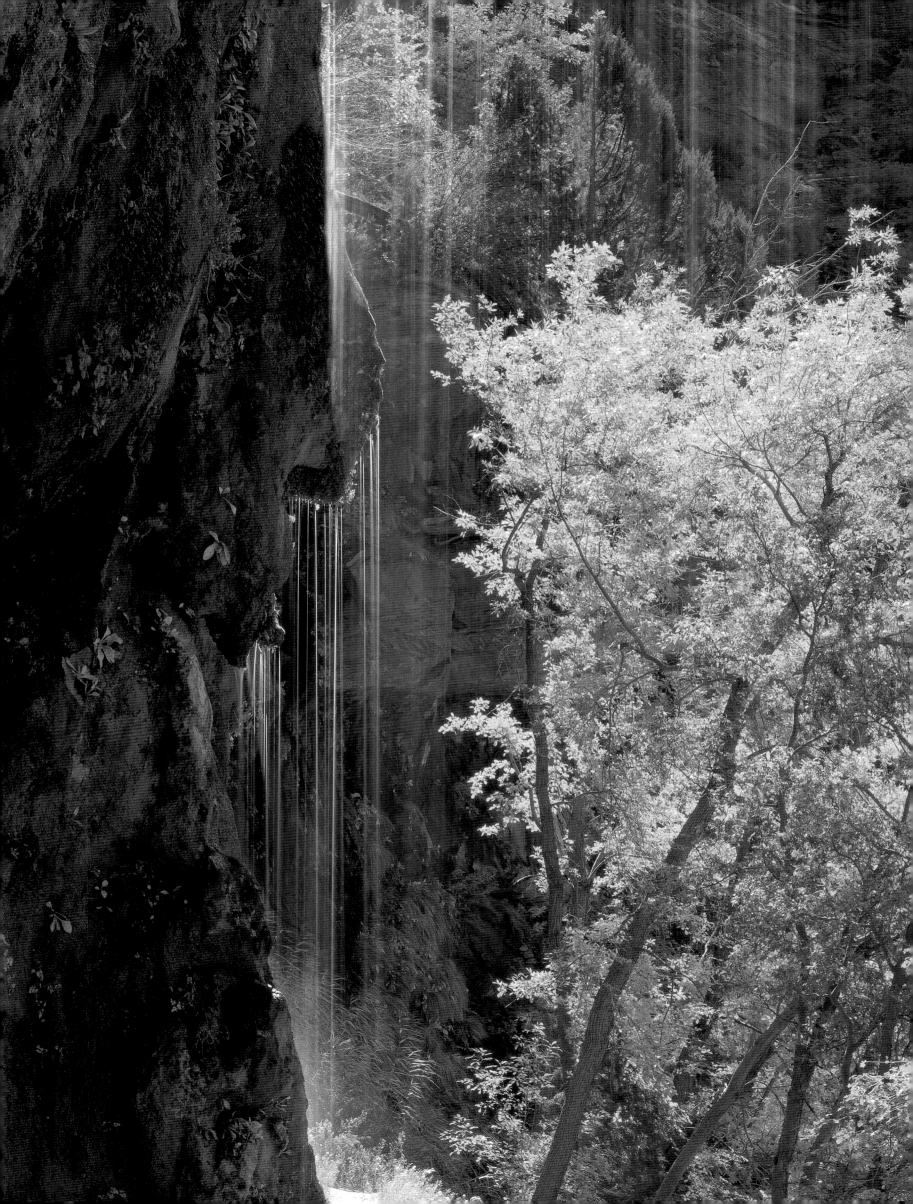

ZION CANYON:

The cliffs of Zion Canyon seen from Scout Lookout. PHOTO © SCOTT T. SMITH

"Excuse me, miss. Can you tell me where is this cable they speak of? I look. I see nothing." The dark young woman with the red Chicago Bulls T-shirt and French accent is seriously perplexed. She is standing at the trailhead leading to Weeping Rock, looking around her blankly.

I suggest we both look east and up the sheer face of 6,496-foot Cable Mountain. You have to scrutinize the shaggy, pine-topped rim of the mountain a bit to make out David Flanigan's 1900 cable works. But when you do, the remains of the old lumber operation are obviously the only man-made structure up there. "Yes. I see it! Thank you so much." She smiles shyly, then continues her slow stroll along the path.

I continue up the steep trail to Hidden Canyon, thankful for an unusually overcast summer morning, which is holding down the temperature. This trail gains nearly 1,000 feet in a mile—enough to get you flushed and sweaty on even a cool day. Definitely not a climb to attempt after early morning in the summertime. At 9 a.m. I meet almost no one on the trail, and those of us up here are quite the United Nations—a Brit, a Frenchwoman, and three parties of young Germans. Zion's reputation goes before her in the world, especially among Europeans.

The rough-surfaced trail begins amid groves of boxelder, velvet ash, cottonwood, and other riparian plants that cluster around Echo Canyon Creek, then zig-zags up the face of Cable Mountain next to Gambel oak and slickrock paintbrush. At one of the bends, I stop to catch my breath, glug some water, and look down the mountain. Knots of visitors are crowded around the cool grotto of Weeping Rock. Shuttles bound for the Riverside Walk follow the road around the Big Bend in the Virgin River as it snakes beneath the Temple of Sinawava. I hear the merry, unconstrained echoes of children's laughter as they paddle in the river. On a day like today, I think of John Muir and the reason he believed so strongly in protection of western lands. "In God's wilderness lies the hope of the world—the great fresh, unblighted, unredeemed wilderness," he wrote. "The galling harness of civilization drops off, and the wounds heal ere we are aware."

Soon I come to a trail junction. The main trail continues to the East Rim—a long, steep hike through Echo Canyon to breathtaking views downcanyon from Observation Point. The trail to Hidden Canyon, my destination, is shorter but provides a few challenges of its own. The trail footing gets rougher after the junction, and in a few places it's so steep and narrow, you need to steady yourself with chains before reaching the water-carved gorge between Cable Mountain and the Great White Throne.

Across the canyon is the island of rock dubbed Angels Landing. The 2.5-mile trail to this high promontory climbs steeply to Refrigerator Canyon, a cool slot in the cliffs. It then gets even harder as you enter Walters Wiggles. (These 21 switchbacks were built in the 1930s by the park's first custodian, Walter Ruesch, and are said to be the only place where you can see both ends of a mule at once.) Scout Lookout is the start of the West Rim Trail and a perfect lunch spot, taking in breathtaking views of Cable Mountain and other landmarks. But it's the side trip from Scout Lookout that draws the crowds: hikers may continue another half-mile using chains to reach Angels Landing itself. Believe me, this is not the place to confront your fear of heights!

There's no hullabaloo at Hidden Canyon. At trail's end, I fit myself into a posterior-perfect depression in the rock and bite into a warm Utah peach, watching water striders and polliwogs skitter on the scummy surface of water-filled potholes. The season is well advanced, and the polliwogs now are trying out their starter frog's legs. Once grown, they will join the amphibian choirs that vocalize nightly in these echoing canyons. The spring songs of canyon tree frogs so inspired Springdale mayor and musician Philip Bimstein, he taped, then "sampled," their sounds and created his own bassoon accompaniment to them. A uniquely postmodern creative response to wilderness if ever there was one!

To reach Hidden Canyon, I climb steps chiseled into slickrock, then scramble over rockfalls chinked with logs and other flashflood debris (a reminder of the ever-present dangers of slot canyons). The canyon is dry, filled with leaf litter that wafts an organic smell as I crush it. Vertical walls of Navajo Sandstone rear

OPPOSITE: Weeping Rock, morning in Zion Canyon. PHOTO © JIM WILSON

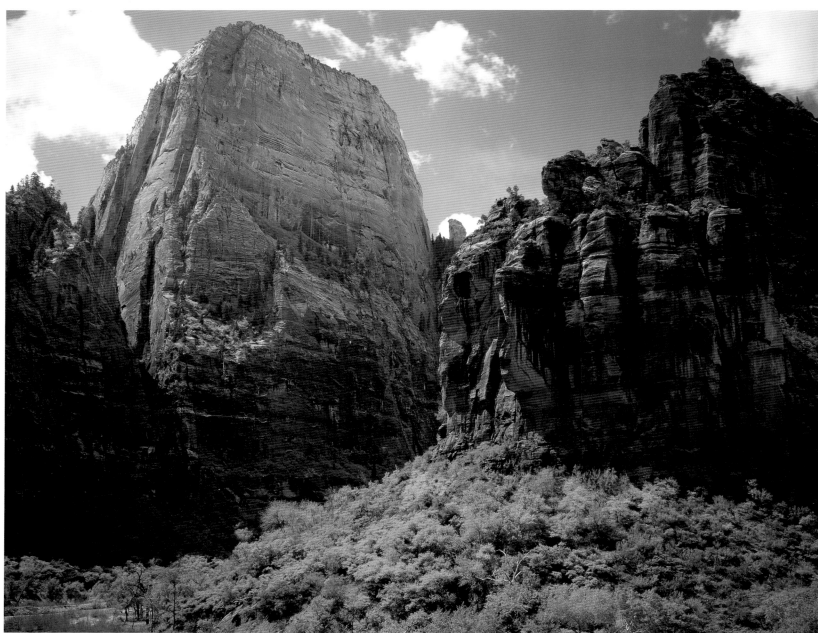

Great White Throne and The Organ, spring morning.

up to my right, while a few feet away, water erosion has carved sinuous folds in rock softened by mosses and lichens. To me, slot canyons are like doorways into a parallel universe, always pulling you deeper and deeper in. Time seems to stand still. The stone corridor narrows and winds, and you're as fascinated about what's on the other side as Edmund in C. S. Lewis's *The Lion, the Witch, and the Wardrobe.*

For now, I resist the temptation to push back any fur coats in the back of the wardrobe and find the kingdom of Narnia. My water bottles are almost empty and my stomach is strongly suggesting it's lunchtime. Reluctantly, I leave the magical grotto and begin my descent, feeling my knee joints spasm slightly. I shrug off their complaints. It's quite an achievement to have an "out-of-canyon" experience in a busy national park in summer, and I'm very grateful. Ssshh! Keep it to yourself.

Bigtooth maples and the Virgin River, autumn.

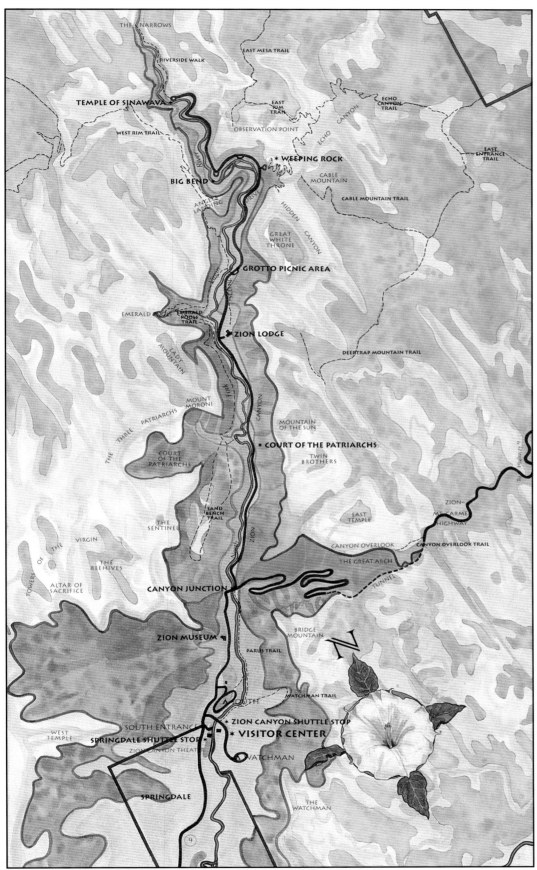

ILLUSTRATION BY DARLECE CLEVELAND

With the exception of the World War II period, travel to Zion National Park has been climbing steadily and in 1995 peaked at 2.5 million visitors a year. The big draw is Zion's spectacular scenery and the chance to experience for oneself the peace of redrock canyons whose name is synonymous with refuge from worldly cares. But, in recent years, many visitors would be more likely to agree with Mormon Church president Brigham Young who, after a particularly trying journey to the canyon in the 1860s, grumpily declared it Not Zion and urged his followers to look elsewhere for salvation.

Brigham Young was famous for his visions and predictions, but even he could hardly have foreseen the modern dilemmas facing Zion: overcrowding, noise, and rushed visitation. During peak season, it's been an elaborate game of Musical Chairs in Zion Canyon—with 3,000 vehicles a day jostling for 250 parking spaces along the 6-mile scenic drive. Something had to be done.

But what? All of the floodplain areas in the narrow upper canyon wide enough to carry parking spaces had already been developed. There simply wasn't room for any more cars. The park decided to get people out of them instead and, in 2000, unveiled an innovative new transportation system within Zion Canyon—the model, it's hoped, for other crowded national parks dealing with similar issues. From Easter through Halloween, 31 propane-powered shuttle buses, carrying 60 passengers each, will run on two loops throughout Springdale and Zion Canyon. The 3.3-mile Springdale loop will include stops at hotels and businesses between the south and north ends of the town of Springdale. The bus on the 8.6-mile Zion Canyon loop will link the visitor center with the top of Zion Canyon Scenic Drive and stop at scenic points along the way.

Parking is available in lots throughout Springdale and at the new, state-of-the-art visitor center. Tour buses have a dedicated lot next to Zion Canyon Theatre. Bus passengers disembark here and cross the Virgin River via a footbridge to reach the visitor center. During peak hours, shuttles will leave every six to 10 minutes from the transportation hub in front of the visitor center, beginning early in the morning and continuing until late evening. Shuttles will operate eight months of the year. The scenic drive will remain open to bicyclists and hikers year-round. For more information, call the park or log onto the Zion website at http://www.nps.gov/zion.

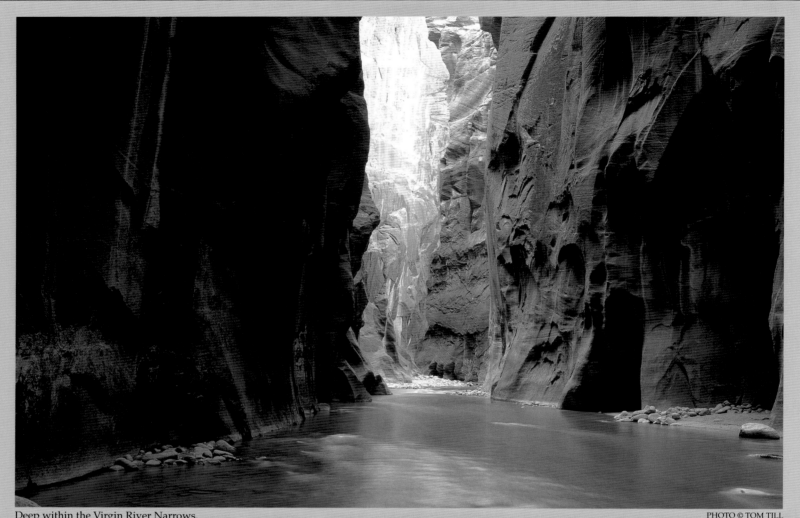

Deep within the Virgin River Narrows.

THE VIRGIN RIVER NARROWS

If the soaring mesa tops of Zion are great cathedrals that inspire the soul with their beauty, then the park's numerous slot canyons—narrow stone passageways carved by silt-laden floodwaters through soft pink sandstone—must be its private chapels for inner reflection.

Shafts of light and shadows paint these stone mazes with chiar-oscuro light that deepens to gloom as the walls close in. Temperatures may be 10 to 20 degrees cooler than in sunlit pockets. Where sandstone meets siltstone, at the bases of the 2,000-foot cliffs, groundwater filtering down through porous rock is forced out as springs and seeps. This is the province of toads, frogs, pearlescent Zion snails, colorful bigtooth maples, singleleaf ashes, and musical canyon wrens. Even the drizzling rocks are alive, cushioned by soft lichens, mosses, ferns, and streamers of livid monkeyflower, columbine, shootingstar, and other water-lovers—all of them breathing oxygen and wellbeing into the lungs of hikers.

Zion's most famous slot canyon is the Virgin River Narrows, a 16-mile-long groove cut deeply into the Markagunt Plateau by the North Fork of the Virgin River, as it drops 1,300 feet to Zion Canyon from near Cedar Breaks. In summer, more than 1,000 people a day wade into the Narrows from its southern terminus at the end of the mile-long Riverside Walk. Most folks go just a short way before turning around. Others wade the 1.8 miles upriver to the junction with Orderville Canyon, a half-day trip. Only the extremely fit and experienced do the whole thing, driving up to the northern trailhead and hiking down overnight. Chest-high water in places, changing weather conditions, obstacles in the river deposited by flashfloods, and fluctuations in temperature and river levels make travel unpredictable. For all but short hikes, carry adequate drinking water, high-carbohydrate food, and a fast-drying, warm coverup in a plastic-lined daypack; wear comfortable, lightweight boots and moisture-wicking, layered clothing to avoid hypothermia from exertion in cool, wet conditions; and use a walking stick to negotiate slippery boulders.

Plan on making the through-hike in early summer or fall, when daily summer thunderstorms aren't a problem. The National Park Service posts daily weather forecasts at the visitor center, where hikers sign up for a limited number of permits to make the overnight hike through the Narrows. Most important of all, learn about flashfloods and how to look for signs of impending danger to avoid becoming one of the many victims claimed by these destructive torrents each season.

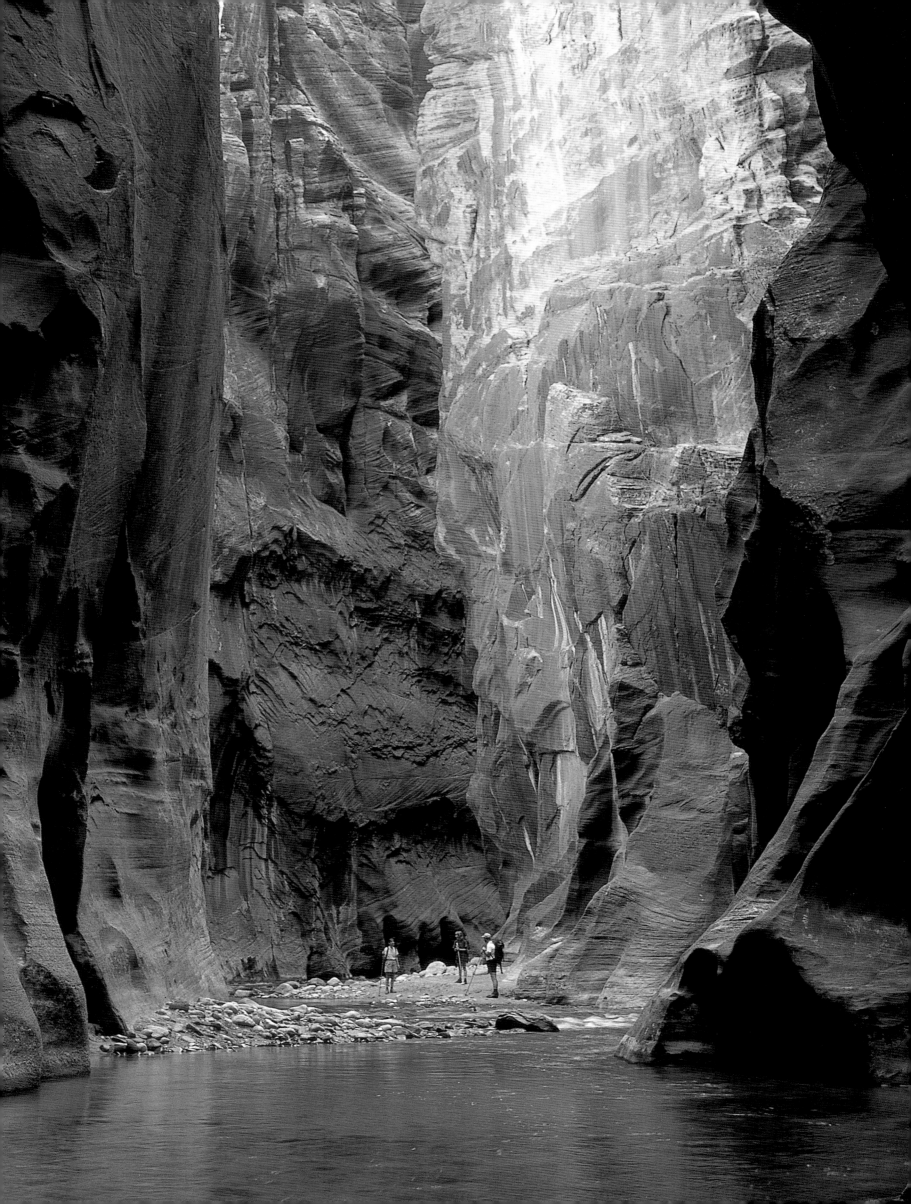

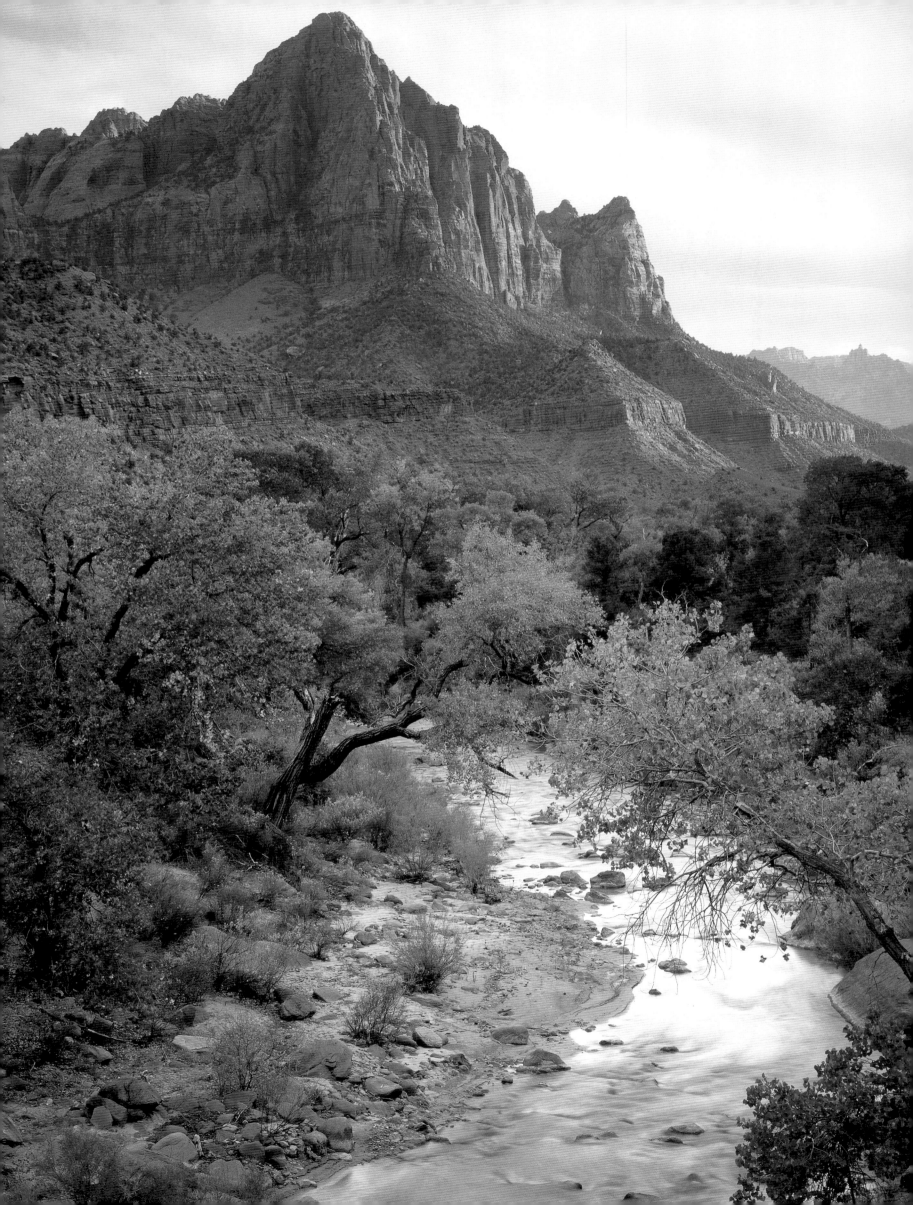

Some 150 miles of maintained trails criss-cross Zion, offering everything from short strolls to long, multiday treks and technical backcountry routes for canyoneers and rock-climbers. Plan hikes with rangers at either Zion Canyon or Kolob Canyon Visitor Centers, taking into consideration your fitness level, time availability, and the season (spring and fall are the coolest times for hiking). Remember: You're in a desert. Wear a hat, sunscreen, carry (and drink) a gallon of water per person per day; eat salty, high-carbohydrate snacks; and leave an itinerary with someone.

Time for only one hike? Make it the paved 1-mile Riverside Walk, which starts at the top of Zion Canyon and follows the Virgin River to the mouth of the Narrows, passing beside dripping sandstone walls softened by grotto gardens. In spring, green-leafed cottonwoods and maples shimmy gaily against red sandstone and blue sky and provide respite from summer's 100-degree heat. Late fall offers a banquet for the senses. Turning leaves explode gold, russet, ocher, and vermilion and twirl along the canyon floor until icicles and snow-dusted cliffs freeze the frame in winter, a scene as picture perfect as a shaken snow dome.

If you're here in a rainstorm, head straight to the Emerald Pools (0.6-mile to the Lower Pool and 1.1 miles to the Upper Pool), where spectacular waterfalls and pouroffs cascade over sheer cliffs and widen the main canyon. Heart-pumping day hikes lead to side canyons high above the canyon floor. One of the most beautiful is Hidden Canyon, which angles off the 10.5-mile East Rim Trail. Hidden Canyon Trail gains 1,000 feet in a mile and is so steep in places, hikers use chains to steady themselves. This is also the case in the last leg of the 2.4-mile trail to Angels Landing, an isolated hunk of rock across the canyon, separated from Scouts Lookout by a narrow fin. The views of upper Zion Canyon and the river 1,600 feet below are unbeatable, but avoid this route if you're afraid of heights.

Scouts Lookout is the terminus of the 15-mile West Rim Trail, the access to the high country. Most hikers head west to Virgin, drive up Kolob Reservoir Road, and hike east overnight from 7,890-foot Lava Point for glorious rooftop views of Zion. The scenic Finger Canyons of the Kolob, in the park's remote western section, offer a more challenging backcountry experience and the chance to hike the 7-mile trail to 310-foot Kolob Arch (permit required), by some measures the world's longest span. From here, you can hike back or climb onto the Kolob Terrace to pick up the West Rim Trail to Zion Canyon.

ILLUSTRATION BY DARLECE CLEVELAND

OPPOSITE: The Watchman and the Virgin River, late afternoon near the terminus of the Parus Trail. PHOTO © LARRY ULRICH

HUMAN HISTORY

The journey from Hurricane to Springdale offers ample proof of what has been true of the Virgin River Valley from the beginning: it's a delightful place to live. The Virgin River loops through a pastoral landscape of small Mormon farming and ranching settlements. Fertile floodplains have been tidied into lush pastures for cattle and horses and fruit orchards. Little rock houses, meeting halls, and churches—many dating from pioneer times— nestle behind English-style cottage gardens of iris, daylily, and other flowers watered by roadside irrigation ditches. And the whole charming scene is framed by fancifully eroded cliffs that offer residents their own private views of the natural world.

Timeless though this scene is, appearances are deceptive. Throughout its history, the Virgin River has been a fickle neighbor—alternately building up floodplains then destroying them during periods of heavy rains and flooding. When Mormon Church president Brigham Young first called his faithful to this remote section of southwestern Utah in the late 1850s, their numbers were large and their dreams larger. After several years of fighting dam breaks, floods, disease, crop failures, infestations, hunger, and unhappy Indian neighbors, families often moved elsewhere. Look around today, and the evidence of these forfeited dreams is everywhere. Many towns lost homes and arable land during the Great Flood of 1861–1862 and built more secure settlements on higher ground at Rockville and Springdale, Duncan's Retreat, Adventure, Grafton, Shunesburg—their names evoke a unique pioneer past. In every case the river was the victor; yet, the Mormons have stayed here and through ingenuity, cooperation, and pioneer spirit have made the desert bloom.

Several thousand years ago, the human imprint on Zion was almost nonexistent. Paleo-hunters did some game hunting in the canyons and on the mesas, then camped overnight in alcoves beside streams and sharpened stone tools with which they butchered game. But as their knowledge of the local terrain and its plants and animals grew, people wandered less. They constructed semisubterranean pithouses that were snug in winter and cool in summer and made tightly woven baskets in which they collected and stored, even cooked, seasonal wild fruits and vegetables, roots, berries, and seeds.

The introduction of farming, about 2,000 years ago, revolutionized life in the Southwest and led to a more sedentary lifestyle. In Zion, the first farmers were attracted to the confluence of the North and East Forks of the Virgin River, just downstream of Parunuweap Canyon in Zion Canyon, where there were plentiful water, fertile bottomlands, and higher terraces on which to build. The Virgin Anasazi were a local branch of the wider Ancestral Pueblo culture, which achieved cultural dominance in the Four Corners region a thousand years

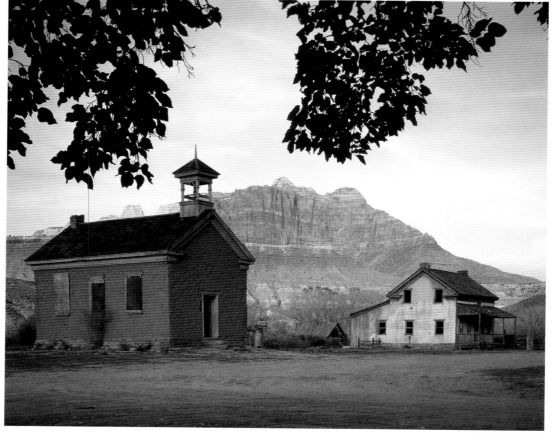

ago. When Spain began colonizing the Southwest in 1540, the conquistadors encountered numerous villages of multistory masonry buildings grouped around a central plaza, with womblike, underground chambers used for seasonal ceremonies. It is by the Spanish word for village, *pueblo*, that we know these ancient people today.

As elsewhere on the Colorado Plateau, the crops that grew best were corn, beans, squash, and other hardy legumes and vegetables that could be planted along washes and streams, harvested, then dried and stored in granaries. To supplement the crops, the men hunted deer, elk, and rabbits as the ancients had done, now using spear throwers known as atlatls, nets, and snares. Most important was the fall harvest of pine nuts, which, along with beautifully executed painted pottery, could be traded with communities as far away as Mexico and the Pacific Ocean.

In the early 1200s, the Virgin Anasazi left and moved to areas with more stable farmlands along the Little Colorado River and the Rio Grande. The Virgin River washed away or buried most signs of their presence in Zion. They were succeeded by small bands of Southern Paiute, whose descendants still live in neighboring communities. Although some archeologists differ in their conclusions, the Southern Paiute consider themselves Numic-speaking cousins to the Virgin Anasazi. From them, they had learned to grow corn and other crops and to build stone homes beside water sources. Individual families of Paiutes (the word Pai in front of Ute means "Utes who live by water") still believe that they are responsible for the springs and streams beside their homes. Their job, they say, is to communicate with the spirits of the rocks, water, plants, and animals that dwell there. Only in this way can har-

mony between man's needs and those of the natural world be maintained. Zion Canyon and the surrounding area remain spiritually important to different bands of the Southern Paiute, particularly the Kaibab Paiute, whose reservation lies south of the park. Tribal members visit sites within the park to gather plants and to make offerings and receive blessings at sacred sites.

Although Spanish and early American explorers passed nearby, the first European to view Zion Canyon is reported to have been young Nephi Johnson, a Mormon missionary and translator, who was led to the mouth of Zion by a Southern Paiute guide in 1858. Yet it wasn't until 1862, when several pioneer farming families founded Springdale that Zion Canyon attracted attention. One settler, Joseph Black, explored the canyon and regaled people with stories that seemed so overblown his neighbors laughingly called the place "Joseph's Glory."

But others took notice. By 1863, Isaac Behunin had built a cabin in Zion Canyon (roughly where the current Zion Lodge is today) and, along with the neighboring Rolfe and Heaps families, was trying to farm the floodplain. It was Behunin, a man who had experienced more than his share of the slings and arrows of persecution, who believed he'd found the biblical Zion described by the prophet Isaiah. "The Lord shall comfort Zion: he will comfort all her waste places; and he will make her wilderness like Eden, and her desert like the garden of the Lord; joy and gladness shall be found therein; thanksgiving, and the voice of melody." Looking around, who could doubt it?

The influx of Mormon pioneers into the Virgin River Valley put enormous pressure on the Southern Paiutes, whose numbers had already been greatly reduced by disease and slavery introduced in the 1700s by Spaniards. The few Paiutes who held on after Mormon colonization found their camps, wild and cultivated crops, and water sources obliterated by livestock. Many Paiutes gave up and moved elsewhere. Those that stayed became dependent on the Mormon newcomers and worked for them as hired help in the home,

on the ranch, and in the mines. Eventually, different bands won the right to small reservations where they could be assured of housing and education, and would be able to continue elements of their traditional life. Today, Southern Paiutes work with the National Park Service to share their enormous fund of specific knowledge about this land and traditional Paiute lifeways. Southern Paiute names are found throughout the Zion area—

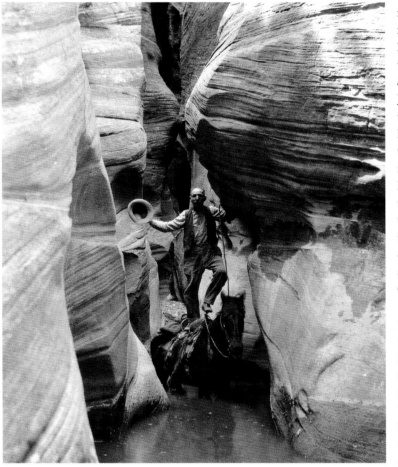

Parunuweap, Mukuntuweap, Paunsaugunt—and reflect the continuing connection the people have with this place.

In 1872, Behunin sold his holding in Zion Canyon and moved away. That same year, John Wesley Powell visited Parunuweap and Zion Canyons and named the latter *mukuntuweap*, believing this to be the Paiute name for that canyon. Although Southern Paiutes now think that Powell's guides were referring to the lower section of Parunuweap Canyon, Zion Canyon was officially called Mukuntuweap when it was set aside for protection as a national monument in 1909. Only after

Horace Albright, the young acting director of the newly formed National Park Service, visited in 1917 did the old Mormon name of Zion reemerge. The national monument was renamed Zion in 1918 and upgraded to national park status in 1919.

A glowing article about Zion in Scribner's Magazine penned by one of Powell's guides, Frederick Dellenbaugh, appeared in 1904 and, purple prose aside, probably did more for Zion visitation than any other publicity. But in the early days getting to the park was not so easy. At first only a dirt track followed the Virgin River to Springdale through the valley from the west. Then, at the turn of the century, local rancher John Winder improved the old Indian trail to markets and ranches in Long Valley, creating an early East Rim Trail that was later improved by national park officials. In 1913, Utah governor Spry helped get roads built from Cedar City to Springdale. Highway 9, an all-weather paved highway, now links Interstate 15 on the west with Highway 89 on the east, passing through the park and out via the 1.1-mile Zion–Mt. Carmel Tunnel, which opened in 1930.

A post–World War I boom in tourist traffic attracted increasing numbers of travelers to the area. The Utah Pacific Railroad built a railroad link to Cedar City and bought Gronway Parry's buses to transport tourists to nearby parks. In 1927, a branch of the railroad, the Utah Parks Company, constructed Zion Lodge on the site of the old Wylie Way tent camp. The main building of the original Zion Lodge burned down in 1968, but the rustic Western Cabins still stand and, now restored, have been added to the National Register of Historic Places. A visitor center was built on the site of the old Crawford family ranch below the West Temple and Altar of Sacrifice at the South Entrance in the 1950s. It was replaced by a new, solar-powered facility in May 2000. The old building will be converted to a human history museum in winter 2002. There will be no shortage of stories to tell.

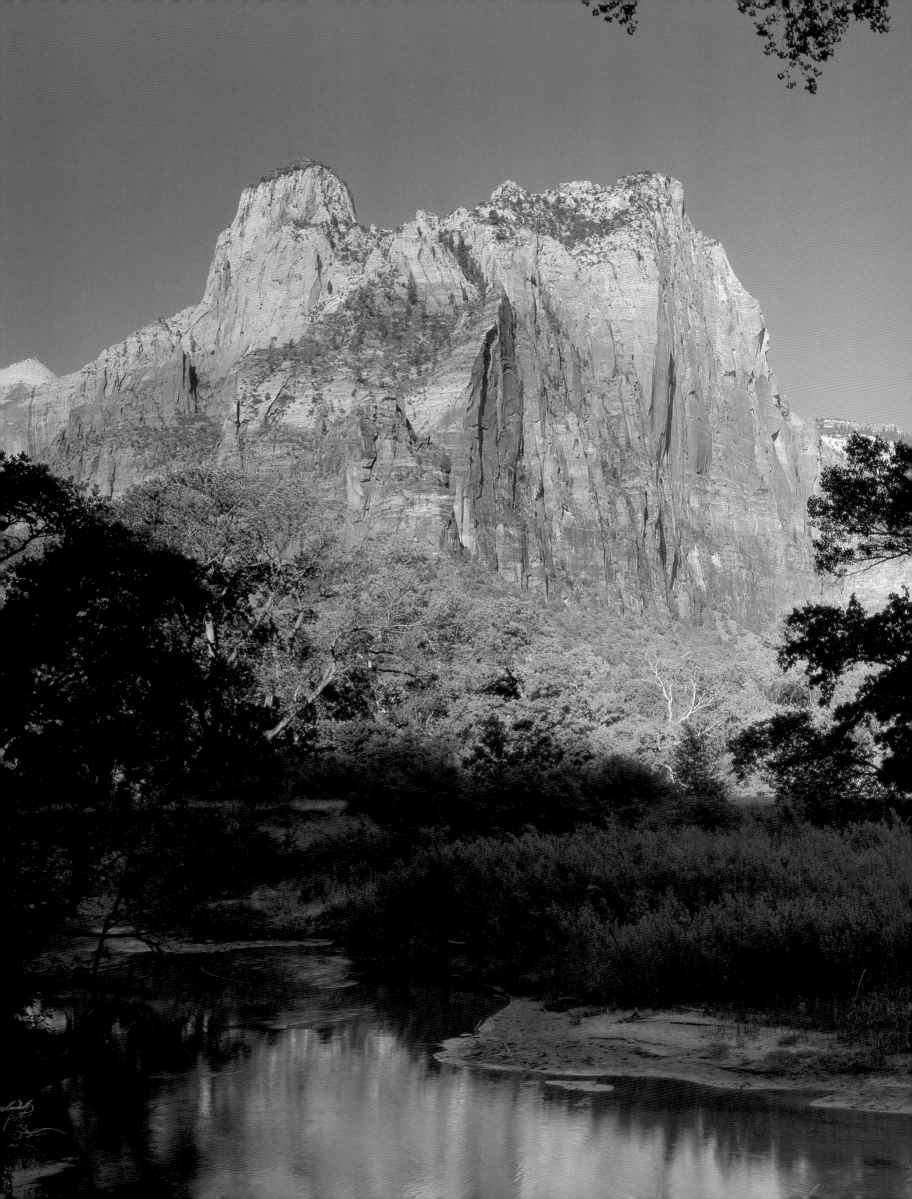

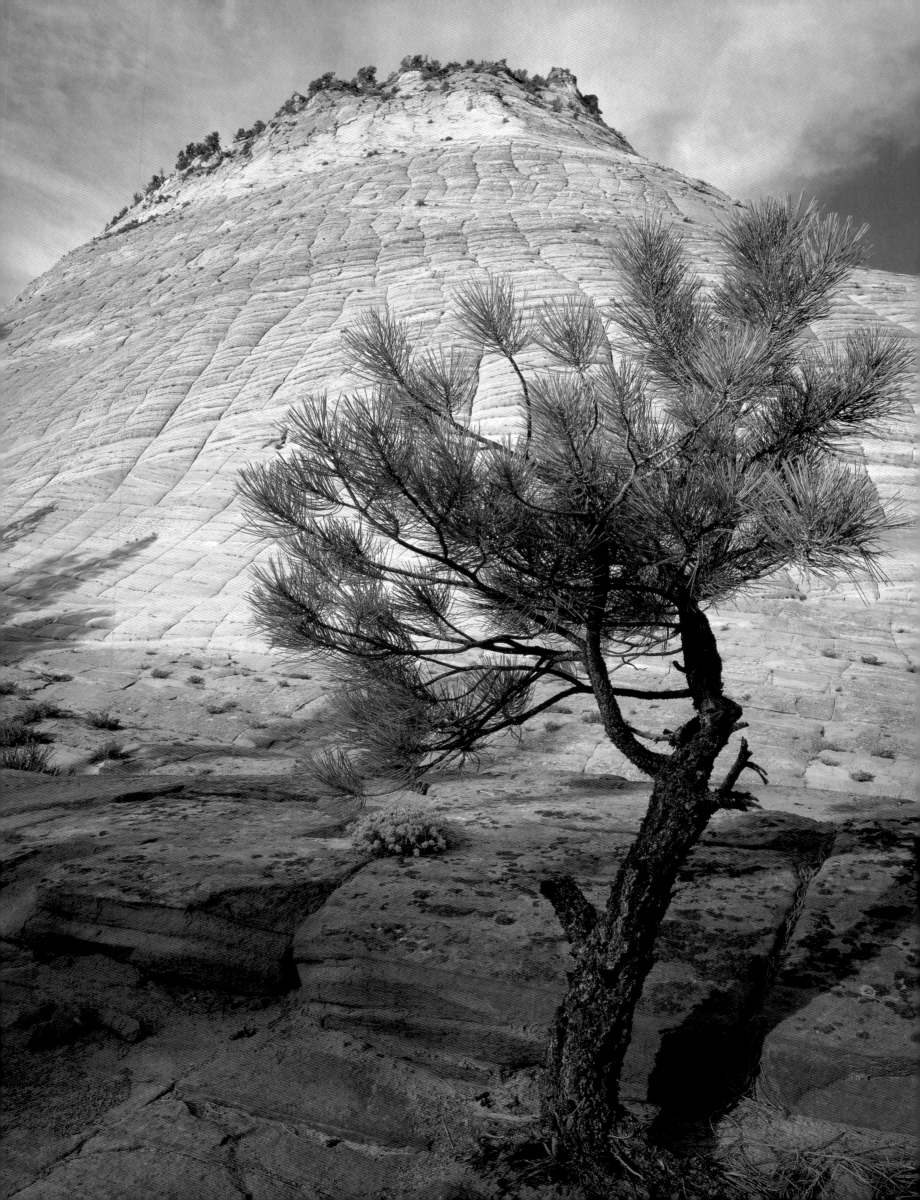

THE EAST SIDE:

Contorted ponderosa pine on hoodoo. PHOTO © JACK DYKINGA

The year was 1923. B. J. Finch of the Bureau of Public Roads and Utah State road engineer Howard Means had arrived in Zion to survey the park for a planned new road tunnel linking Zion Canyon with the East Rim. The men rode across the East Rim with guides from Orderville, then traversed Parunuweap Canyon, but could find no suitable route. Stumped, they drove out around Zion via Kanab, Pipe Spring, and Hurricane and arrived back in Zion National Park to consider the situation.

At this point, acting park superintendent Walter Reusch introduced the two officials to John Winder, a pioneer Rockville rancher. Winder had been exploring the remote high country of the East Rim since 1880. In 1900, he had improved the old Indian trail next to Weeping Rock that accessed the forested rim country and was now summering his cattle up there. The barely passable trail was steep, narrow, and dangerous, and Winder still looked for a better solution. He remembered that fellow Rockville rancher Elijah Newman had claimed that timber could be brought down from Cedar Mountain via Pine Creek Canyon. Winder's plan, therefore, was simple: blast a tunnel through the Great Zion Arch above Pine Creek, an eastern tributary of the Virgin River, and build a road through the canyon.

He escorted the two men to the East Rim, where they walked down Pine Creek Canyon to study the terrain. It was decided that problems with grade and outlet precluded a tunnel through the arch. But the cliffs to the south of Pine Creek would do fine. Pioneer ingenuity had triumphed again.

In the early days, the remote backcountry around Zion Canyon was known only to a few hardy individuals. All that changed when improved trails and roads were built in the park in the 1920s and 1930s. Today, vehicle access via the East Rim is easy. Highway 9—which, in the park, has been colored red by cinders to match the cliffs—follows a circuitous route from the park's East Entrance then enters the Zion–Mt. Carmel Tunnel and descends Pine Creek Canyon to Zion Canyon via a series of steep switchbacks.

The East Rim is the best place in Zion to get a feel for the metamorphosis of sand to sandstone and back again. Despite their great age, the towering cliffs of pale, swirling Navajo Sandstone look barely petri-fied. You can even tell which way the Jurassic wind was blowing when the 3,000-foot dunes were deposited by looking at the cross-bedding in the rocks. Groundwater moving vertically through the sandstone has fractured the cliffs further, giving the rocks a tesselated look, as if they might shatter into a million pieces any moment. At night, the deep water-carved passageways between Checkerboard Mesa and its companions become acoustically enhanced amphitheaters for frogs and hunting corridors used by bats, owls, coyotes, and other nocturnal ramblers.

There are deliberately few trails here. Winder's 10.5-mile East Rim Trail has been improved on its 3,000-foot ascent from Weeping Rock trailhead to Echo Canyon and up to Observation Point. From here to its terminus at the East Entrance, the East Rim Trail still offers plenty of adventure and side trips to Deertrap and Cable Mountains. The most accessible of the East Rim trails is the half-mile Canyon Overlook Trail next to the East Portal of the Zion–Mt. Carmel Tunnel. It may well provide the most unusual view of Zion Canyon and a superb introduction to some of Zion's key natural features.

The trail sits directly above the Great Arch of Zion and was built by the Civilian Conservation Corps a few years after the tunnel was completed. It ascends steep stone steps at the start then passes through a typical Southwest high-desert zone of pinyon, juniper, and scrub oak beside the Pine Creek Narrows. Shady alcoves allow moisture-loving boxelder to get a toehold. In exposed areas, pricklypear cactus, silvery buffaloberry, and manzanita nestle between rocks.

Along the trail you get to see what happens when two rock strata with wildly different characteristics meet. The quartzite grains of Navajo Sandstone are loosely cemented by calcium carbonate, silica, and iron oxide (hematite), which wash out when groundwater passing down through the rock encounters the relatively impermeable Kayenta below. The water exits as springs that destabilize and erode the rocks, creating shady overhangs along the trail. The back of one alcove is lined with seeps; it is a dank place brightened by an unexpected hanging garden of ferns, mosses, and water-loving flowers in spring and early summer.

OPPOSITE: Ponderosa pine at the base of Checkerboard Mesa. PHOTO © JC LEACOCK

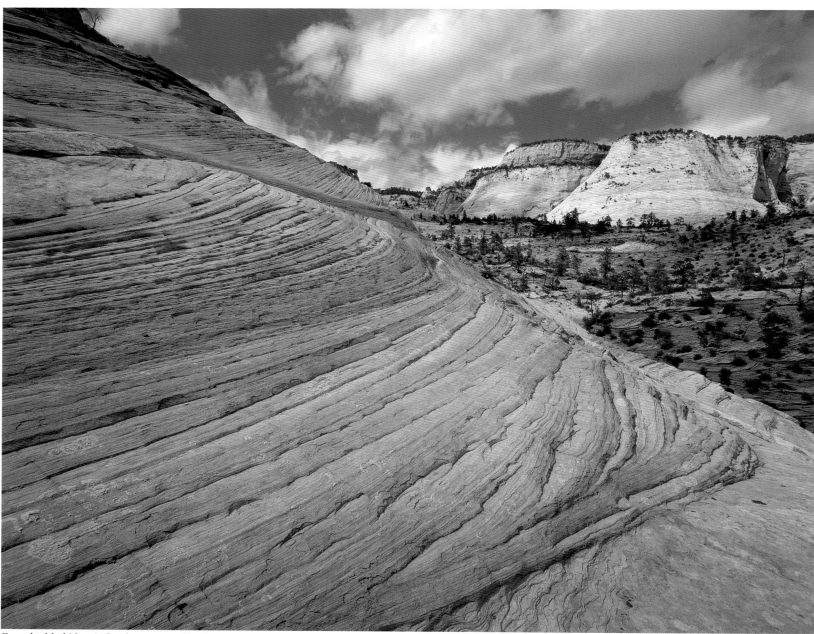

Cross-bedded Navajo Sandstone near Checkerboard Mesa.

Water pouring over rock has created zebralike mineral stripes on cliff faces. Some cliffs have a bluish-black shiny patina that is composed of 30 percent manganese and iron oxide and 70 percent clay. Groundwater flushes out minerals from the rock and onto the surface, where they pass through a film of clay particles trapped by bacteria living on the surface of the rock. Even the tiniest organism in this desert environment has a role to play.

At trail's end is a dramatic overlook with sweeping views of the lower end of Zion Canyon. Immediately below is Pine Creek Canyon. To the west are the West Temple, the Beehives, and the Sentinel—the landmarks that cluster at the mouth of upper Zion Canyon. To the south you can see the five gallery windows of the tunnel where, in the less busy early days of Zion, visitors could stop the car to admire the view. Standing up here, with the wind in your hair, you wonder what Old Man Winder might have said about the modern park. Perhaps, "If you build it, they will come."

Bigtooth maple, autumn along Clear Creek.

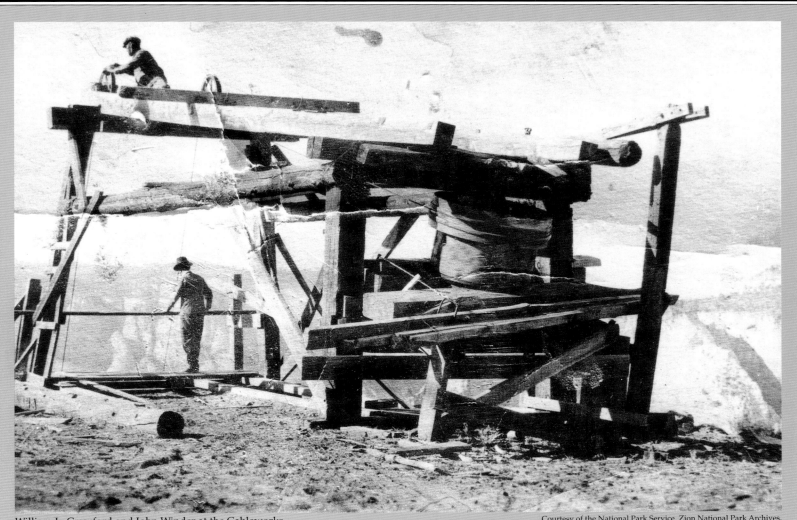

William L. Crawford and John Winder at the Cableworks.

THE ZION CABLE

David Flanigan was reared on tales of Brigham Young's 1863 visit to Zion Canyon. With the nation on the brink of the Civil War, Young had exhorted the exhausted and disheartened Mormon colonists to remain faithful to their plan of building self-sufficient communities in southern Utah. To inspire them, he related a vision he had had on first seeing Zion: one day good ponderosa pine lumber for building would fly down from the mountain tops to the canyon floor "as a hawk flies."

Few believed it possible. Now, 25 years later, 15-year-old David Flanigan had an idea about how to fulfill Young's prophecy. He would build a cable tramway, similar to the one used to lower mail over the cliffs in Shunes Canyon. "It will work," he told his brother William. "For I will build it so that it will."

Not until 1901 would Flanigan find a way to realize his dream. In an isolated area with little organized business and industry, no one was interested in investing time and money in such a cock-eyed plan. To convince them, Flanigan decided to build a demonstration wire pulley system down the mountain. He was helped in 1900, when John Winder improved an old Indian trail up the side of Cable Mountain. Winder drove bolts into the rock and laid logs across them, thereby reducing a 10-day wagon train ride to a six-hour climb. Using the "short-cut trail," Flanigan could get up the mountain in no time and experiment with his cable.

Finally, in August 1901, with the help of family members, friends, and fellow settlers, the young inventor completed his wire works, and the first load of lumber was lowered to the canyon floor. In 1904, he bought an old sawmill and began cutting lumber for sale—a task that his brother William complained would soon make "old men of them." Three years later, the Gifford, Crawford, and Stout families purchased the wire works, installed heavier cable, and upgraded the sawmill engine.

Though never commercially viable, the cable became a symbol of community pride and faith and provided lumber for local buildings and homes, including, in 1927, Zion Lodge. A few daredevils rode the cable down the cliff seated atop loads of lumber. One, 300-pound Frank Petty, Sr., a later mill operator, got stuck and had to be rescued by his son. Amazingly, no one lost their lives riding the cable, but the cableworks proved fatal for several unfortunate bystanders. When a schoolteacher was killed by the rusting lower works in the 1930s, they were removed, leaving only the upper works visible today.

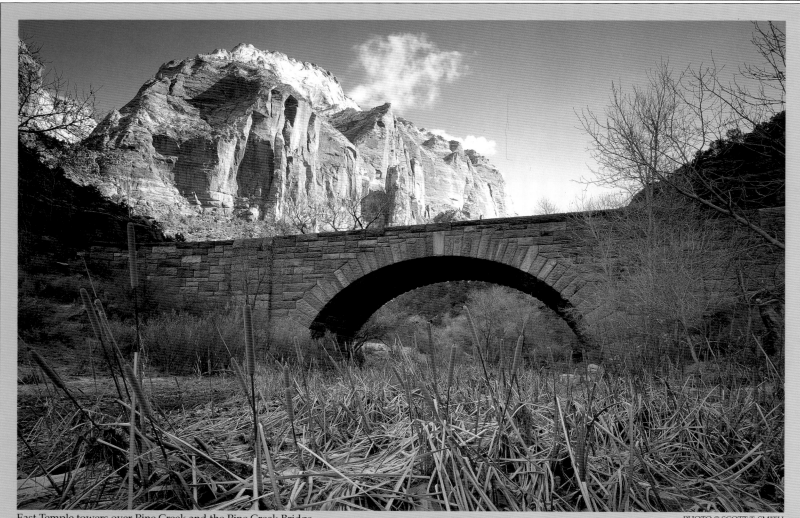

East Temple towers over Pine Creek and the Pine Creek Bridge. PHOTO © SCOTT T. SMITH

TUNNELS, BRIDGES & BUILDINGS

Almost as memorable as Zion's naturally sculpted cliffs and canyons is the park's man-made architecture, which harmonizes with the sandstone setting in a unique national park interpretation of the oft-repeated adage "form ever follows function."

The log-cabin–style Western Cabins (remnants of the 1927 Gilbert Stanley Underwood-designed Zion Lodge that burned in 1968) exemplify National Park Service Rustic architecture. This building style dominated park architecture in the 1920s and 1930s and required buildings and other man-made structures, such as gates, fireplaces, water fountains, curbs, bridges, retaining walls, and road systems, to match their surroundings in scale, materials, and color.

Pine Creek Bridge, both skillfully engineered and aesthetically pleasing, is an acknowledged work of art. Built in 1930 entirely of Navajo Sandstone with a cemented rubblestone core, it has a massive supporting key in the upper center of a barrel that reaches 23 feet high at the center point. As a final flourish, the mason used hand-hewn sandstone slabs reflecting all the colors of Zion—tan, brown, pink, red, purple, even green.

Pine Creek Bridge sits below six switchbacks, which rise 3.6 miles up Pine Creek Canyon to the park's engineering masterpiece: the 1.1-mile Zion–Mt. Carmel Tunnel. Opened in 1930, after nearly three years' construction, the tunnel burrows through the cliffs of the East Rim at 5,600 feet elevation, then connects to Highway 89 via an all-weather road to Mt. Carmel. Federal funds paid for the tunnel, and state and federal government officials oversaw its execution. But much of the work was done by local men, who hired on with the Nevada Contracting Company and worked on either the road crew building the switchbacks or the mining crew blasting out the 16-foot-high, 22-foot-wide tunnel.

In 1933, Zion received 200 young male recruits in Franklin D. Roosevelt's new Civilian Conservation Corps, organized during the Great Depression as a government-funded labor force on federal projects throughout the United States. The young men of "Roosevelt's Tree Army" were regarded as an expression of the resurgence of America's pioneer beliefs because they brought back visions of a lost frontier, the perfectibility and promise of youth, and the therapeutic powers of the wilderness. In Zion, they constructed trails, houses, and park buildings and quarried and shaped stone at a quarry, a mile west of Springdale. Most importantly, the CCC built and maintained irrigation canals, including the pioneer-built Crawford-Gifford, Pine Creek, and Oak Creek Canals, providing a visible link between the pioneers who built the irrigation canals and the youngsters who sought to emulate them years later.

OPPOSITE: Iron-capped hoodoo near Clear Creek. PHOTO © JEFF D. NICHOLAS

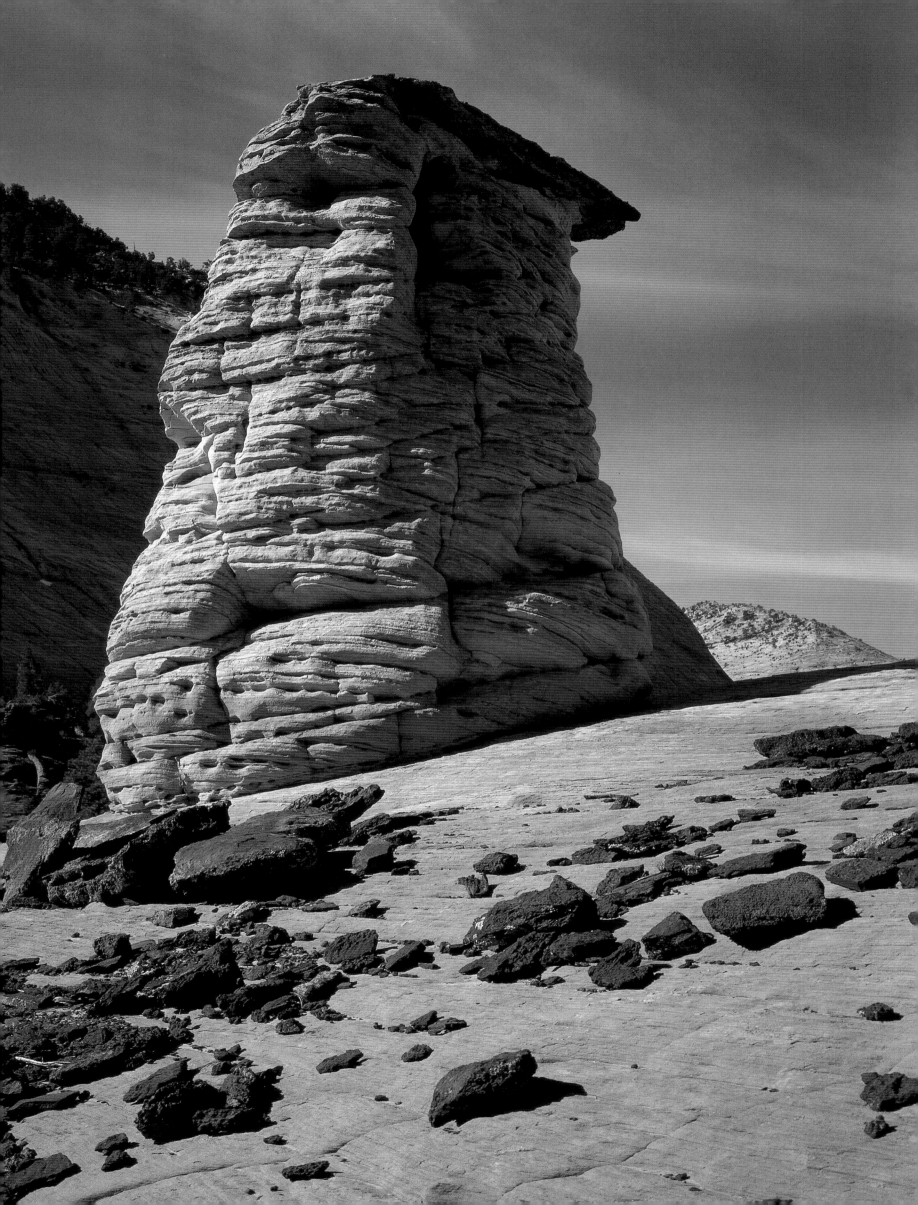

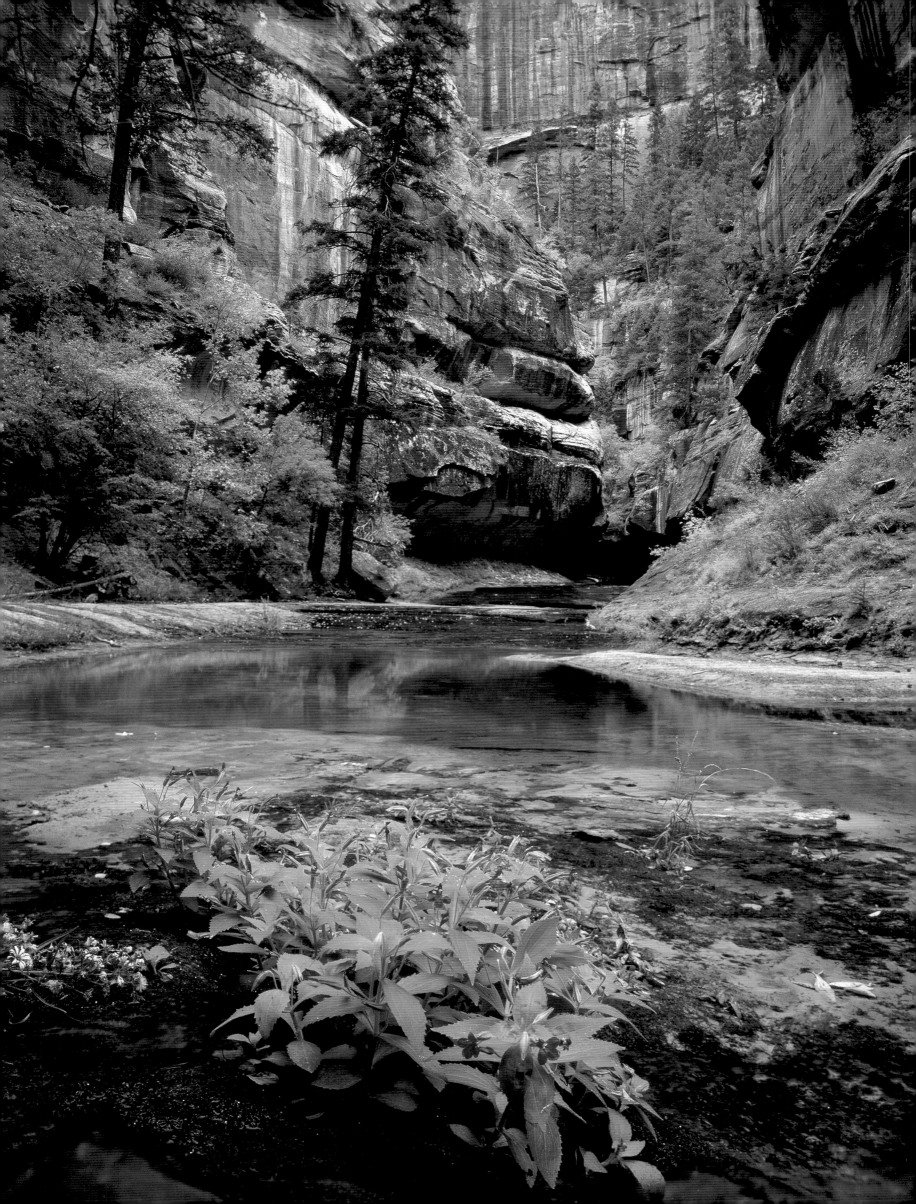

THE WEST SIDE:

Late afternoon in Cave Valley, Lower Kolob Plateau. PHOTO © D. A. HORCHNER

One of the unwritten laws of the universe is that any food eaten outside tastes better. Add to that a little outdoor exercise at elevation and a fine campsite, and, well, a modest black-bean burrito can seem like the plat du jour at the latest Santa Fe eatery.

Or so it seems to me and my trail buddy Jeff as we polish off the last of the chips and salsa at our Kolob campsite. We rub our stomachs happily and settle down to some postprandial ruminations over a glass of excellent Dewars, lazily watching a ground squirrel, attracted by food preparations in camp, making a tactical assault on my food box. Will this little beggar be bold enough to jump on the table and actually ask for a handout, we wager? But it loses interest and scampers into the aspens, where the dappled late-afternoon light camouflages it from view.

We've spent the afternoon hiking the 6-mile Wildcat Canyon Trail, which follows the rim of a canyon cut by one of the creeks on the upper Kolob Plateau. After setting up camp in the primitive Lava Point Campground, we drove down to the West Rim Trail trailhead, the upper access for Wildcat Canyon. Compared with the 15-mile West Rim trek, this spur trail is a breeze, dropping 500 feet in elevation to Wildcat Creek, regaining the elevation on the other side, and coming out near Great West Canyon, a deep canyon system carved by the forks of North Creek, a major western tributary of the Virgin River. Trail's end is just off Kolob Reservoir Road, a paved backway that leaves Highway 9 at Virgin and winds up onto the 9,000-foot upper Kolob Plateau.

In its lower reaches, the Kolob is a lush world of red cliffs, golden grasslands, and rugged, almost impenetrable canyons. The road climbs in and out of national park and private lands through pinyon-juniper forest, ponderosa pine, and finally aspens, subalpine firs, and meadows and ponds snugged against black lava cliffs. The land is quiet and remote but not unpeopled. Local ranchers have grazed livestock here since pioneer times, and residents of surrounding lowland communities build cool summer getaways on private parcels to escape the furnacelike desert heat.

One-tenth of a mile from the main trailhead, we turned south at the Wildcat junction and entered a subalpine meadow of long grasses that partially hid an old grain drill. It's early August-the end of the wildflower season. Lupines have that exhausted, anemic look, but their neighbors, scarlet Gilia and Indian paintbrush, are still strutting their stuff for Jeff's videocamera. The thin, crystalline air makes every detail jump out: a mosaic of limestones arranged as if by some unseen hand; a fragile lemon-yellow butterfly, wings spread and motionless on a pale, rough rock; a stand of ethereal dandelion clocks backlit by sunshine; the strange, raised hieroglyphic patterns made by insects boring beneath the silvery bark of aspens in the boulder-choked dry creek bottom.

As Jeff relaxed into filming mode, murmuring editorial notes to himself like a distracted professor, I scouted ahead, moving rhythmically through the landscape, imprinting it on my senses. Where are those wild cats, I wondered? The trail betrayed no obvious paw prints or scat, but I knew Felis concolor was keeping an eye on things from a hidden ledge somewhere nearby. Zion's ecosystem is largely intact, from the largest predators to the tiniest organisms, which is one thing that makes it special. Knowing this sharpens the senses in the backcountry, where staying alert is a good habit to cultivate.

Something we are not paying enough attention to in camp that evening is an approaching summer storm. After dinner, we have just lit the stove to boil water for tea when the sky suddenly turns sullen and black-bellied cumulus clouds race in like storm troopers. The wind starts rattling the tent stakes and treetops. In minutes, what began as a few far-off flashes and brief grumbles quickly turns into a full-scale argument of Zeus-like proportions directly overhead, complete with lightning and thunderbolts. We barely have time to pull our gear under the picnic table before a vertical downpour sluices down upon us. We're soaked even before we reach cover. The stove sputters and goes out.

Like all summer storms this one is soon over. Thrilled, we race down to the Lava Point overlook, hoping to catch sight of its departure. A shaft of pink sunset light is illuminating Zion Canyon, bathing the tops of the West Temple, Smithsonian Butte, and other landmarks in an unearthly glow. One-hundred-mile views

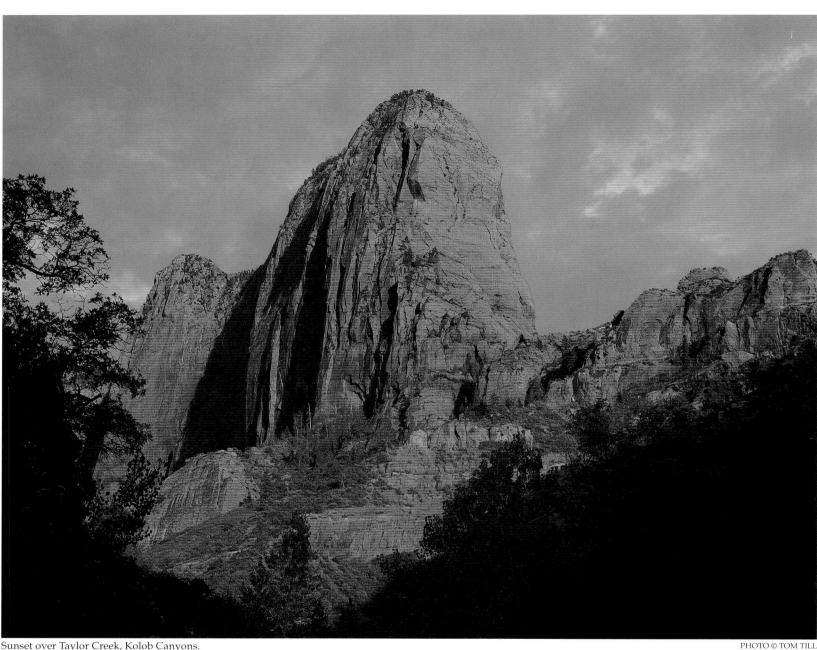

Sunset over Taylor Creek, Kolob Canyons.

take in the whole of the southeastern Markagunt Plateau. To the south, sandwiched between the North Rim of the Grand Canyon and the Vermilion Cliffs, is the Arizona Strip, homeland of the Kaibab Paiute. To the east, the entire Grand Staircase is visible, rising from the Grand Canyon to the Pink Cliffs of Cedar Breaks and Bryce Canyon. Talk about perspective.

In the foreground, the Virgin River drainage is so deeply etched, it's easy to see why the Paiute call this section of the Markagunt *I-oo-goon*, or "canyon like an arrow quiver." But at this moment, with the light draining from pink to purple to rose and gray, it is the Mormon name for the upper plateau that seems most fitting: Kolob, or "the star closest to the throne of God." As sunset fades and night reveals a rash of stars in the freshly washed inky sky over Zion, heaven, does, indeed, feel very near.

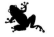

Inside Double Arch Alcove, Taylor Creek.

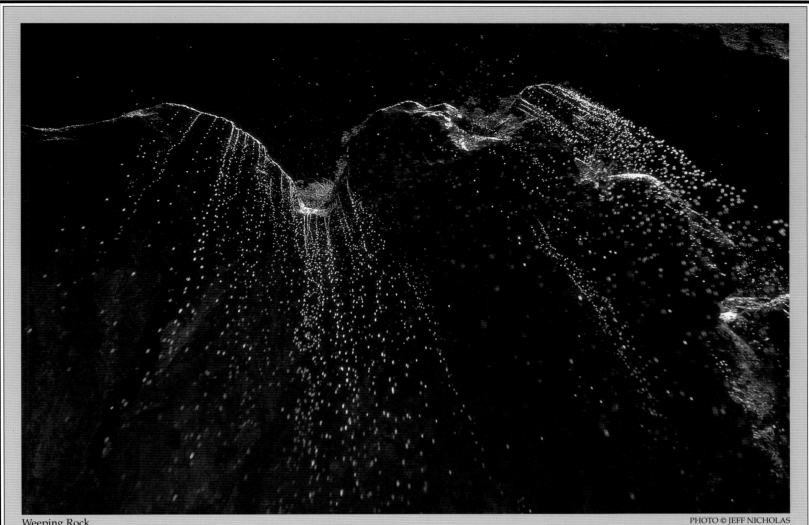

Weeping Rock.

PHOTO © JEFF NICHOLAS

PLANT & ANIMAL COMMUNITIES

Flora and fauna of four different life zones—desert, riparian, woodland, and coniferous forest—are found within the park. But with the Great Basin, Mojave, and Colorado Plateau deserts converging here and fluctuations of temperature, moisture, exposure, and soil type in this canyon-and-mesa topography, Zion's hugely diverse flora and fauna never ceases to amaze naturalists.

At the lowest elevations, look for plants and animals adapted to desert conditions in canyon-bottom meadows and rocky ledges. Waxy-coated pricklypear cactus nestles beside woody sagebrush and rabbitbrush, tough-stemmed Indian paintbrush, and poisonous sacred datura, while several varieties of milkvetch and prince's plume occupy sandy, selenium-rich soil pockets. Desert animals keep cool in burrows, dens, or among slickrock ledges in the daytime. Desert cottontails, jackrabbits, Merriams kangaroo rats, and others become active at dusk or dawn, timing their movements to avoid coyotes, gray foxes, ringtails, and other predators. Most visible in the daytime are rock squirrels, pinyon jays, and the occasional whiptail lizard or other reptile disturbed by passing feet.

On mid-elevation slopes, between 3,900 feet and 5,500 feet, cooler conditions support pygmy forests of pinyon and juniper, as well as scrub oak, interspersed with shiny-barked manzanita, narrow- and broad-leafed yucca, fra-

grant cliffrose, and rugged serviceberry. Above 6,000 feet, stands of ponderosa pine and Gambel oak appear, wafting vanilla and piney scents on the warm breeze. Higher up, the pines are joined by groves of quaking aspen. On the upper Kolob Plateau, the dominant vegetation is subalpine fir, whose tall, umbrella shape shrugs off deep winter snows that cover the Markagunt Plateau. The highlands are the province of secretive mountain lions, which may travel up to 100 miles, pursuing mule deer, from rim top to canyon bottom.

The cliff tops, walls, ledges, and side canyons are ideal places to observe red-tailed hawks, golden eagles, white-throated swifts, endangered peregrine falcons, and young California condors, which were bred in captivity and released in the Vermilion Cliffs in the mid-1990s. Perhaps you'll also glimpse reintroduced bighorn sheep, which hide in side canyons and among ledges, or, at dusk, encounter one of 19 species of bat that drink from pools and hunt insects nightly.

Seeps, waterfalls, streams, and potholes are magnets for frogs, toads, and other amphibians that enjoy the dripping grottoes and hanging gardens next to springs. For the riparian community, though, nothing beats the North and East Forks of the Virgin River and its tributaries. Here, dense communities of Fremont cottonwood, boxelder, maple, willow, and velvet ash share the river with bank beaver, gnatcatchers, water striders, and warm-water fish like the endemic Virgin spinedace and flannel-mouth sucker.

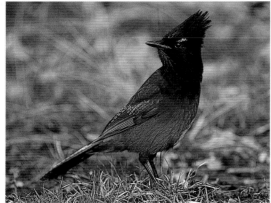

Stellers jay. PHOTO © TOM & PAT LEESON

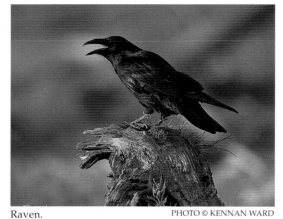

Raven. PHOTO © KENNAN WARD

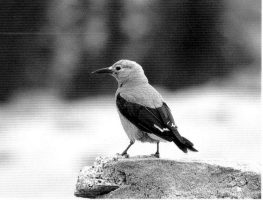

Clarks nutcracker. PHOTO © KENNAN WARD

In 1999, biologists counted 289 bird species in Zion. Many are year-round residents. Others, like the Virginia's warbler and other songbirds, are migrants along the Virgin River corridor, attracted by dense riparian foliage that offers nesting sites and easy access to a daily smorgasbord of aquatic insects and fish.

Often seen in the shallows is the dipper, or water ouzel, a small, plump, slate-gray bird that grips the river bottom while prospecting for insects and tiny fish and sings loudly enough to be heard above the roar of the river. Also heard, though rarely seen, is the canyon wren. A modest little brown bird with a long, curved bill, it hides among the ledges but gives the game away with its song—a haunting, downward-lilting tune that bounces off canyon walls.

You'll remember you're in a desert when you see the brightly topknotted roadrunner among cactus and sagebrush on the canyon floor. Roadrunners eat lizards and rodents, as well as insects and scorpions and, when surprised, run rapidly but rarely fly. Other nonfliers are wild turkeys, which have become common in Zion's coniferous forests. Turkeys were domesticated by ancient Pueblo people, who used their feathers in robes.

Pinyon-juniper woodlands provide both cover and nutritious pinyon nuts and juniper berries in early fall for spotted towhees, the most abundant bird in the park. Another "P-J" resident is the pinyon jay, a large, light-blue bird related to the crow. Like other corvids, pinyon jays go about in flocks, argue loudly, and display opportunistic behavior—in this case, a penchant for hoarding pinyon nuts and stealing other birds' nests. Ravens, the largest birds in this family, are frequently seen circling overhead. Their blue-black funereal plumage, enormous beaks, and overall size distinguish them from crows. All corvids are very intelligent. Some pairs work campgrounds for scraps, perching on branches and offering stereophonic caws, kronks, and a whole repertoire of opinions.

Ravens share the skies with a variety of raptors, which nest in aeries on cliff ledges. Endangered peregrine falcons, speed merchants that plummet at 100 mph from cliff top to canyon bottom, prey on fellow cliff-dwelling white-throated swifts and have even been known to harass larger and slower golden eagles. In 1999, park archeologists witnessed a truly extraordinary sight. While monitoring the historic cableworks atop Cable Mountain, they looked up and saw another endangered species, reintroduced young condors from the Vermilion Cliffs, surreptitiously stealing a compass from a backpack. This time, there wasn't a thing the outraged peregrines or humans could do about it.

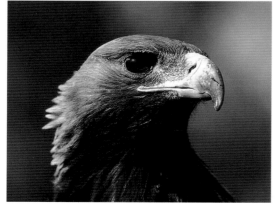

Golden eagle. PHOTO © KENNAN WARD

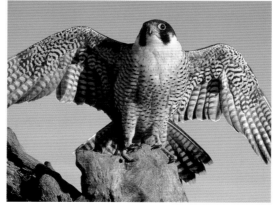

Peregrine falcon. PHOTO © KENNAN WARD

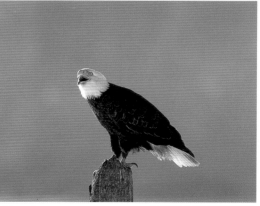

Bald eagle. PHOTO © KENNAN WARD

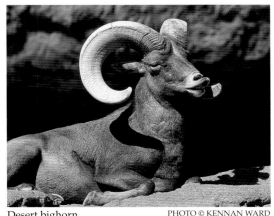
Desert bighorn. PHOTO © KENNAN WARD

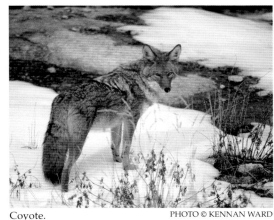
Coyote. PHOTO © KENNAN WARD

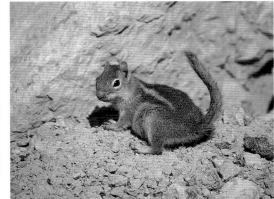
Golden-mantled ground squirrel. PHOTO © CAROL POLICH

Zion is home to 75 mammal species, from large carniverous predators at the top of the food chain to palm-sized bats, which consume thousands of insects nightly. About half the mammal population are rodents. Gray-brown rock squirrels, the largest of the ground squirrels, are the most commonly seen mammals in Zion. They live among rocks and, when agitated, emit high-pitched chittering sounds that are often mistaken for bird calls. Squirrels visit campsites hoping to supplement their diet of acorns, nuts, seeds, cactus, and agave. Their antics are certainly cute, but feeding them is illegal and may lead to a nasty bite that may transmit plague or other diseases.

Another distinctive rodent is the kangaroo rat, so named for its long hind legs. Merriam's and chisel-toothed kangaroo rats live in sandy burrows and have evolved so that they need never drink water, metabolizing all they need by recycling wastes from

seeds. Herbivorous desert cottontails and black-tailed jackrabbits graze on grasses and plants on the canyon floor and in the woodlands. If you think the jackrabbit looks like a hare, you'd be right. It uses its large, strong back legs to outrun predators, while its trademark ears radiate heat from its body via a network of capillaries.

At night, cottontails and jackrabbits are on red alert for predators like ringtails and coyotes. Ringtails are related to raccoons but without the trademark eye mask. They feed on mice, rabbits, snakes, insects, and fruit and make dens among rocks or boulders. Coyotes are the smallest members of the wild dog family and, with their eerie yips and howls at dusk and dawn and ubiquitous presence, may be the signature animal of the West. Like the ringtail, they eat a wide variety of foods and have been known to down a deer or elk, working in packs. Their fur is characteristically redder and browner at

lower elevations and more gray and black in the high country.

The principal predators of coyotes in the wild are cougars, or mountain lions. But mountain lions far prefer mule deer, which browse on vegetation throughout the park. Mountain lions follow mule deer herds and cull sick and older members, thereby strengthening the stock. The mountain lion shies away from man, but its presence is often announced by fresh paw prints at water sources in the early morning or scat along the trail.

Chipmunk. PHOTO © DICK DIETRICH

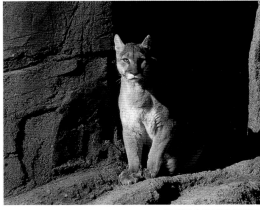
Mountain lion. PHOTO © KENNAN WARD

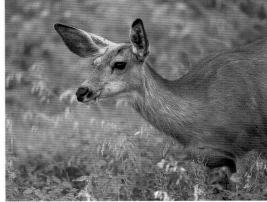
Mule deer. PHOTO © KAREN WARD

Spadefoot toads. PHOTO © LARRY ULRICH

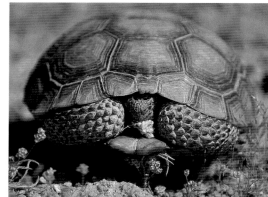

Desert tortoise. PHOTO © CAROL POLICH

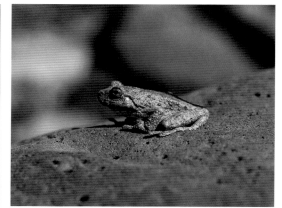

Canyon tree frog. PHOTO © FRED HIRSCHMANN

There are 32 species of reptiles and amphibians in Zion. Reptiles tend to prefer desert scrub areas where they can move between sun and shade to regulate body temperature. Amphibians, such as frogs and toads, are found near rivers, creeks, springs, and pools throughout the park and are more often heard than seen.

Look for the beautiful collared lizard, which measures 8-12 inches and has a blue-green body and black-and-white collar. Collared lizards eat other lizards and may become aggressive and bite if disturbed. They flee danger by lifting their bodies and tails up and dashing away on hind legs. Also quick on their pins are plateau and western whiptails. Their name comes from the way they whip their long tails back and forth as they run. Like other lizards, they can detach their tails when seized by predators, then grow a new one.

Snakes live at all elevations and, like other reptiles, spend much of the day under rocks, keeping cool, then warming up by basking in the sun. The coachwhip may be the fastest snake in North America and hunts lizards, crickets, small rodents, and other snakes in the daytime, which it then slowly digests whole. Its multihued skin—gray, brown, tan, yellow, and pinkish—has no distinct pattern. Visitors are often more concerned about the western rattlesnake. Aggressive when disturbed, it is occasionally sighted but should pose few threats if you watch where you walk and where you place your hands when resting. Remember: this is the rattlesnake's home; you are the visitor.

Canyon streams and pools in Zion jump nightly with a wide variety of small frogs, toads, and newts, including tree frogs, leopard frogs, red-spotted toads, Woodhouse's toads, and western spadefoot toads. The two-inch spadefoot uses its spade-shaped feet to dig itself into the bottom of dried pools during the dry season. It can stay this way, protected by a mucous coating, for years. The signal to awaken comes when heavy summer rain moistens its subterranean home. The spadefoot sings loudly to attract a mate, then indulges in long nights of passion to ensure the continuation of his line. Perhaps the oddest amphibian is the canyon tree frog, which hangs out on rocks beside streams, not in trees as its name suggests. Its call is a loud, decidedly unfroggy bleating, which when multiplied sounds like a flock of sheep run amok.

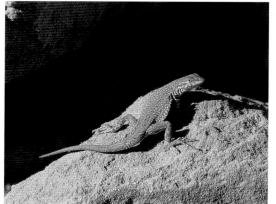

Sideblotched lizard. PHOTO © CAROL POLICH

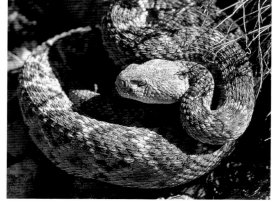

Western diamondback rattlesnake. © KENNAN WARD

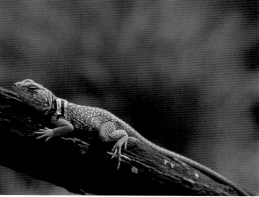

Collared lizard. PHOTO © JEFF NICHOLAS

Paintbrush on slickrock. PHOTO © JEFF D. NICHOLAS

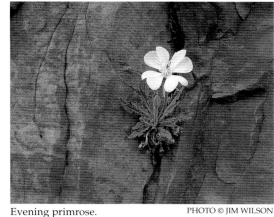

Evening primrose. PHOTO © JIM WILSON

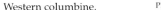

Palmer penstemon. PHOTO © JEFF D. NICHOLAS

The wildflower season begins in Zion Canyon in March and continues through October. High-country bloomers have just a few weeks after the snow melts in late May in which to put on their finery, lure pollinators, and reproduce. Autumn then reverses the color show. Hue-changing oaks, maples, and aspens flare across the highlands in September, with the show-stopping Technicolor finale in Zion Canyon in early November.

Along the canyon bottoms are plants associated with the Great Basin Desert and, in the Coalpits section of the park, the Mojave Desert. In May and June, pricklypear cactus sprout psychedelic-colored flowers to advertise their wares to insect pollinators. If successful, they will produce ruby-red fruits in fall that animals and humans enjoy. Plants of the sagebrush community include fragrant sand verbena, globemallow, and Indian paintbrush. All is not as it appears with paintbrush. It partially parasitizes the roots of other plants and its "flowers" are really red bracts and sepals that obscure the tiny green flowers. A subspecies, slickrock paintbrush, roots in sandstone crevices beside the Echo and Hidden Canyon Trails.

Milkvetch, or *astragalus*, a member of the pea family, is widespread at low elevations in Zion, where several varieties occupy selenium-rich soils found in Chinle Formation ledges. Milkvetch is easily identified by its trailing habit, many pairs of opposite small leaves, and dainty heads of purple, pink, or yellow flowers. It is profuse in early spring along the Angel's Landing Trail below Refrigerator Canyon and Coalpits Wash. An endemic vetch, St. George milkvetch, lives in Kolob Canyon.

Lupines are generally found in ponderosa pine and aspen forests keeping company with sunflowers, asters, balsamroot, scarlet Gilia, and paintbrush in summer. A low-elevation species, broadleaf lupine, grows along Oak and Birch Creeks. Another recognizable high-country flower is penstemon. Fifteen species live in Zion—ranging in color from purple to red to pink. All have elegant trumpet flowers beloved by hummingbirds. Smooth penstemon is endemic to the Zion area and starts blooming in spring near Checkerboard Mesa.

The most miraculous of all Zion microenvironments are the shady, dripping canyons, which attract plants that like to keep moist. Next to the Emerald Pools, Riverside Walk, and Weeping Rock Trails, pink Zion daisy, starry white false solomon seal, spurred golden and western columbine, and helleborine orchid peep out shyly from maidenhair fern and moss enclaves. In May, look for lovely Zion shootingstar, a member of the primrose family. Its backswept purple petals reveal its yellow stamens as it nods in the cool spray.

Spiderwort. PHOTO © LARRY ULRICH

Western columbine. PHOTO © JEFF D. NICHOLAS

Desert four o'clock. PHOTO © JEFF D. NICHOLAS

PAGE 44/45: Rain swollen waterfalls in Heaps Canyon (Emerald Pools area). PHOTO © LARRY ULRICH

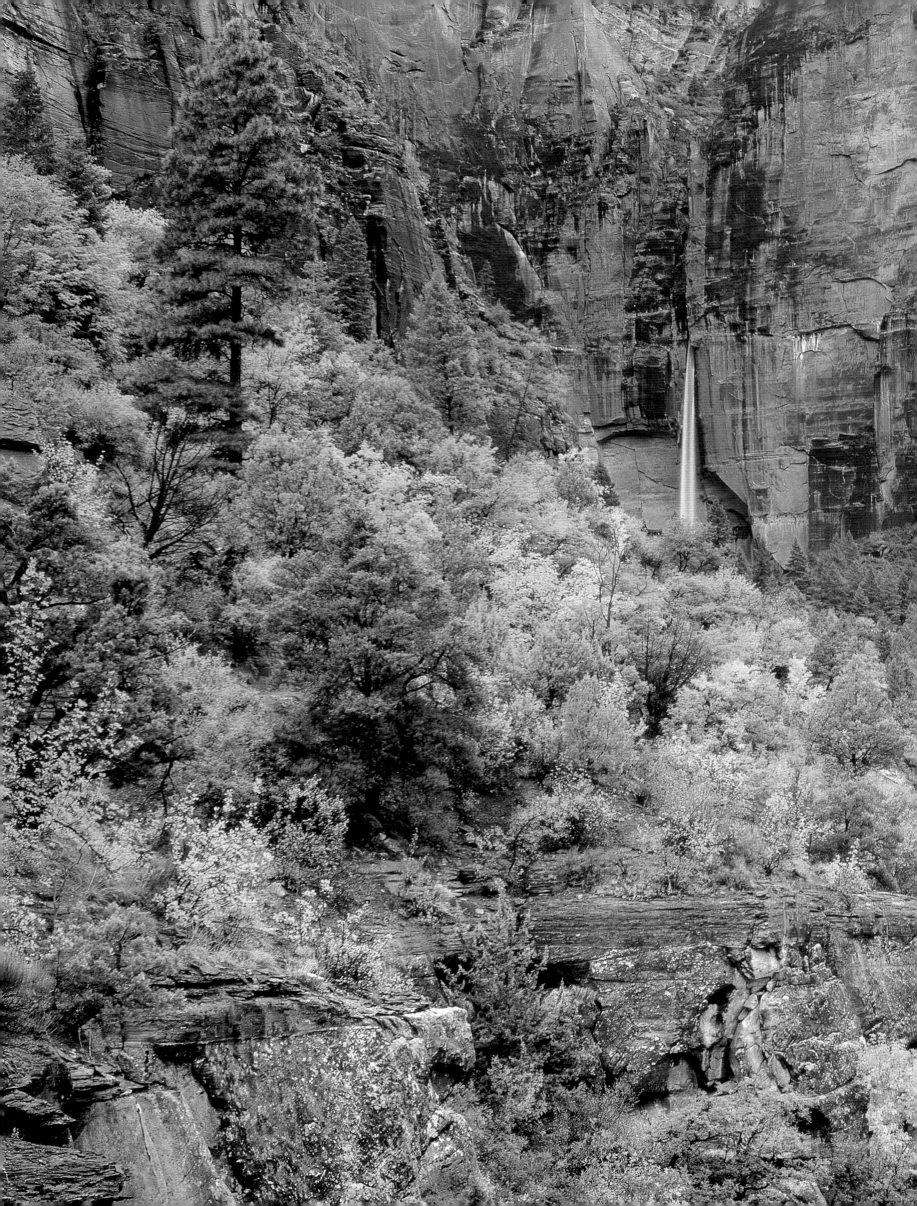

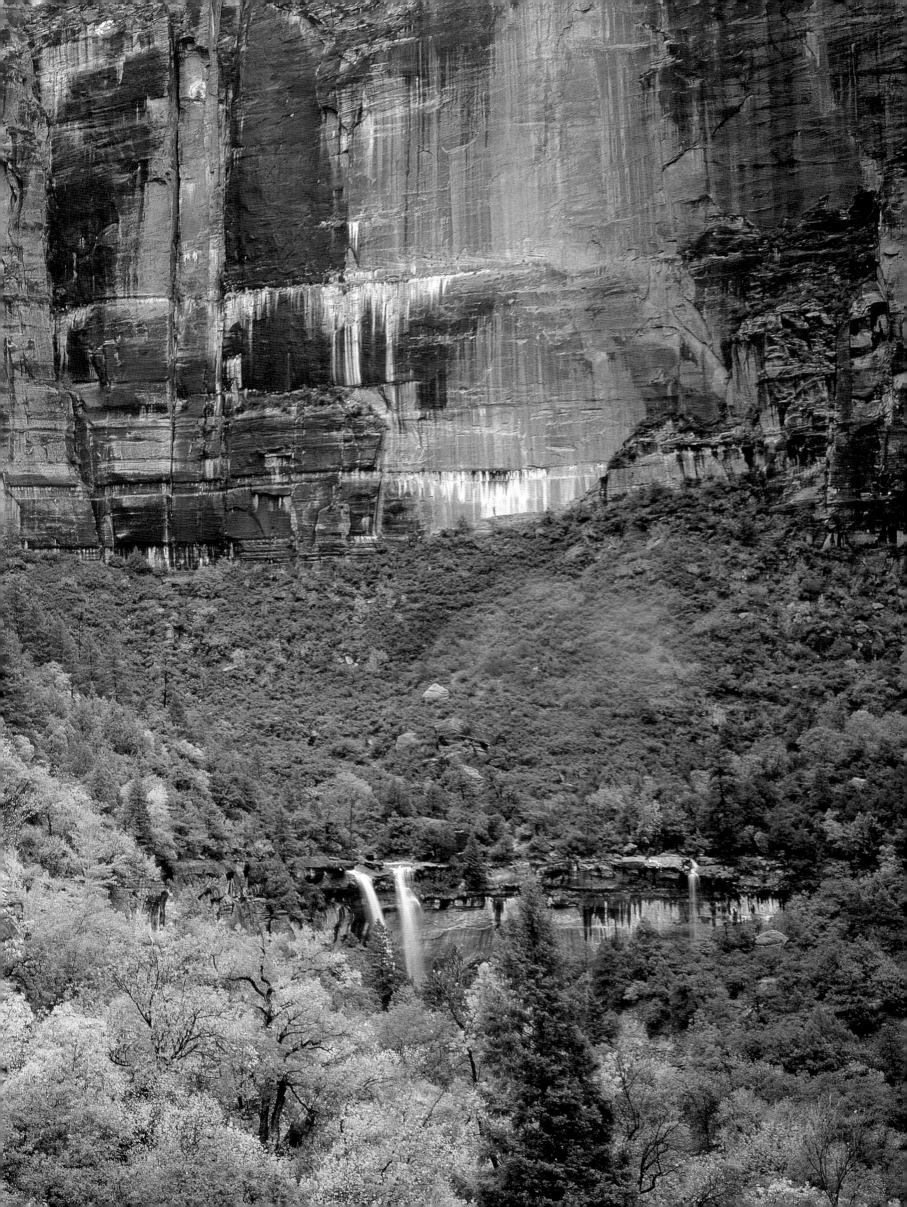

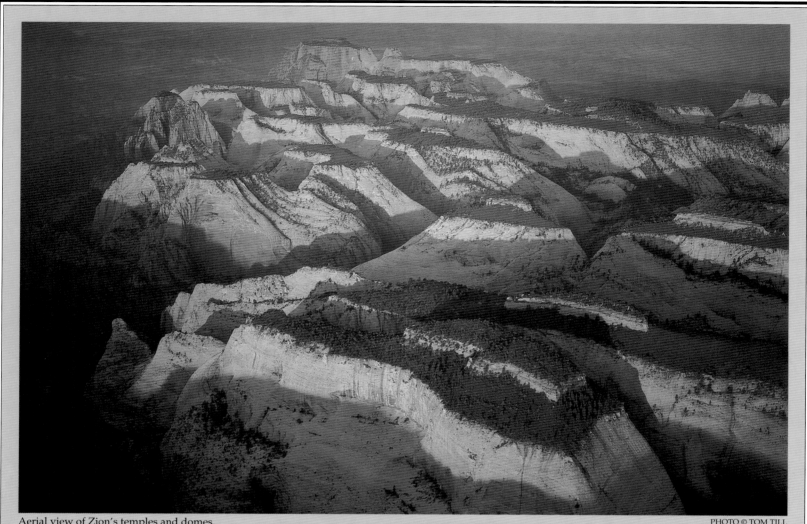

Aerial view of Zion's temples and domes.

ZION'S UNIQUE ENVIRONMENT

Hundreds of plants and animals find sanctuary in Zion. Of these, some of the most important are species listed as endangered or threatened. Native desert bighorn sheep disappeared due to over-hunting, habitat loss, and disease but were reintroduced into Parunuweap Canyon, an area of restricted visitation, in 1973. They are sometimes seen among open cliffs, but they avoid forested and low-lying areas, where they may become prey for cougars.

Endangered peregrine falcons inhabit 15 known territories in cliffs throughout the park. These areas are closely monitored in spring for nesting sites, which are then closed to climbers until the season is over. Another endangered species, the Mexican spotted owl, also breeds here. Twenty pairs nest in caves and ledges in 17 dispersed territories throughout the park, primarily deep, steep-walled canyons. The owls hunt for wood rats at night and are rarely seen.

The park is monitoring impacts on the large number of algaes and mosses that live in the Virgin River and undergo heavy trampling by the more than 1,000 people a day who wade a short way up the Narrows in summer. One Narrows resident not in any danger at present is the endemic Zion snail, a tiny mollusk that lives in hanging gardens and winters in crevices. It has evolved an enormous foot, which allows it to stay suctioned to slick walls during heavy flows. Zion snails appear to be thriving, with numbers in the millions in some locations.

Protecting Zion's riparian habitat is a high priority for the park. In 1996, Zion became the first Utah park to win a water rights settlement agreement granting it consumptive and reserved water rights and prohibiting construction of any dams on the main stems of the Virgin River within two miles of park boundaries. The agreement, signed but not yet ratified, recognizes preexisting water rights and dams on North and Shunes Creeks.

This is good news for native fish communities of the Virgin River. Speckled dace, Virgin spinedace, flannelmouth sucker, and desert sucker have experienced population declines outside the park due to habitat loss and fragmentation and to competition from introduced nonnative species. Native fish have relatively intact populations in Zion, but Virgin spinedace have been so impacted elsewhere they only live in the park. It is hoped that a conservation agreement, signed by the National Park Service and other federal and state agencies in 1995 to prevent endangered species listing, will help the fish rebound.

RESOURCES & INFORMATION

EMERGENCY & MEDICAL:
24-HOUR EMERGENCY MEDICAL SERVICE
Dial 911, or (435) 772-3322

ROAD CONDITIONS:
ARIZONA (520) 779-2711
COLORADO (303) 639-1111
NEVADA (702) 486-3116
NEW MEXICO (800) 432-4269
UTAH (801) 964-6000

FOR MORE INFORMATION:
ZION NATIONAL PARK
Springdale, UT 84767
(435) 772-3256
www.nps.gov/zion

ZION NATURAL HISTORY ASSOCIATION
Springdale, UT 84767
(435) 772-3264
www.zionpark.org

NATIONAL PARKS ON THE INTERNET:
www.nps.gov

BUREAU of LAND MANAGEMENT
176 East DL Sargent Drive
Cedar City, UT 84720
(435) 586-2401
www.blm.gov

COLOR COUNTRY TRAVEL REGION
PO Box 1550
St. George, UT 84771
(800) 233-8824
www.utahscolorcountry.org

DIXIE NATIONAL FOREST
82 North 100 East
Cedar City, UT 84720
(435) 865-3700
www.fs.fed.gov

UTAH STATE PARKS
1636 West North Temple
Salt Lake City, UT 84116
(801) 538-7720
www.nr.state.ut.us/parks/utahstpk.htm

UTAH TRAVEL COUNCIL
Council Hall/Capitol Hill
Salt Lake City, UT 84114
(800) 200-1160
www.utah.com

LODGING INSIDE THE PARK:
AMFAC PARKS & RESORTS
14001 E. Iliff, Suite 600
Aurora, CO 80014
(303) 29 -PARKS
www.amfac.com

CAMPING INSIDE THE PARK:
Phone (800) 365-CAMP (2267),
On the Internet: www.reservations.nps.gov

LODGING OUTSIDE THE PARK:
COLOR COUNTRY TRAVEL REGION
PO Box 1550
St. George, UT 84771
(800) 233-8824
www.utahscolorcountry.org

KANE COUNTY TRAVEL COUNCIL
78 South 100 East
Kanab, UT 84741
(800) 733-5263
www.kaneutah.com

TRAVEL SERVICES UTAH
(800) 259-3843, or on the Internet:
www.zionpark.net

OTHER REGIONAL SITES:
BRYCE CANYON NATIONAL PARK
PO Box 170001
Bryce Canyon, UT 84717

CEDAR BREAKS NATIONAL MONUMENT
PO Box 749
Cedar City, UT 84720
(435) 586-9451

CORAL PINK SAND DUNES STATE PARK
PO Box 95
Kanab, UT 84741
(435) 648-2800

GLEN CANYON NATIONAL RECREATION AREA
PO Box 1507
Page, AZ 86040
(520) 645-2471

GRAND STAIRCASE–ESCALANTE NAT'L MONU.
PO Box 246
Escalante, UT 84726
(435) 826-5499

LAKE MEAD NATIONAL RECREATION AREA
601 Nevada Highway
Boulder City, NV 89005-2426
(702) 293-8907

MESA VERDE NATIONAL PARK
Mesa Verde National Park, CO 81330
(970) 529-4461

MONUMENT VALLEY NAVAJO TRIBAL PARK
PO Box 360289
Monument Valley, UT 84536
(435) 727-3353 or 727-3287

NAVAJO NATIONAL MONUMENT
HC 71, Box 3
Tonalea, AZ 86044-9704
(520) 672-2366 or 672-2367

PETRIFIED FOREST NATIONAL PARK
PO Box 217
Petrified Forest, AZ 86028
(520) 524-6228

PIPE SPRING NATIONAL MONUMENT
HC 65, Box 5
Fredonia, AZ 86022
(520) 643-7105

SNOW CANYON STATE PARK
PO Box 140
Santa Clara, UT 84765-0140
(435) 628-2255

WUPATKI & SUNSET CRATER
NATIONAL MONUMENTS
2717 N. Steves Blvd., Suite 3
Flagstaff, AZ 86004
(520) 556-7042

SUGGESTED READING:
Brereton, Thomas and James Dunaway. *EXPLORING THE BACKCOUNTRY OF ZION NATIONAL PARK: Off-trail Routes*. Springdale, UT: Zion Natural History Association.

Crawford, J.L. *ZION NATIONAL PARK: Towers of Stone*. (1988) Reprint. Springdale, UT: Zion Natural History Association. 1996

Garate, Donald T. *THE ZION TUNNEL: From Slickrock to Switchback*. Springdale, UT: Zion Natural History Association. 1989, revised 1991.

Hamilton, Wayne. *THE SCULPTURING OF ZION: With a Road Guide to the Geology of Zion National Park*. Springdale, UT: Zion Natural History Association. 1984, revised 1992.

Leach, Nicky. *KOLOB CANYONS–ZION NATIONAL PARK: Next To The Throne Rooms of God*. Springdale, UT: Zion Natural History Association. 1994.

Leach, Nicky. *PIPE SPRING NATONAL MONUMENT: An Ancient Oasis on a Storied Frontier*. Springdale, UT: Zion Natural History Association. 1994.

Stegner, Wallace. *MORMON COUNTRY*. New York, NY: Bison Books. 1942, 1970.

Telford, John & Williams, Terry Tempest. *COYOTE'S CANYON*. Salt Lake City, UT: Peregrine Smith Books. 1989.

Warneke, Al and Nicky Leach, contributing editor. *AN INTRODUCTION TO THE GEOLOGY OF ZION*. Springdale, UT: Zion Natural History Association. 1993.

Welsh, Dr. Stanley A. *WILDFLOWERS OF ZION NATIONAL PARK*. Springdale, UT: Zion Natural History Association. 1990.

Williams, Terry Tempest, William B. Smart, and Gibbs M. Smith, editors. *NEW GENESIS: A Mormon Reader on Land and Community*. Layton, UT: Gibbs Smith, Publisher. 1998.

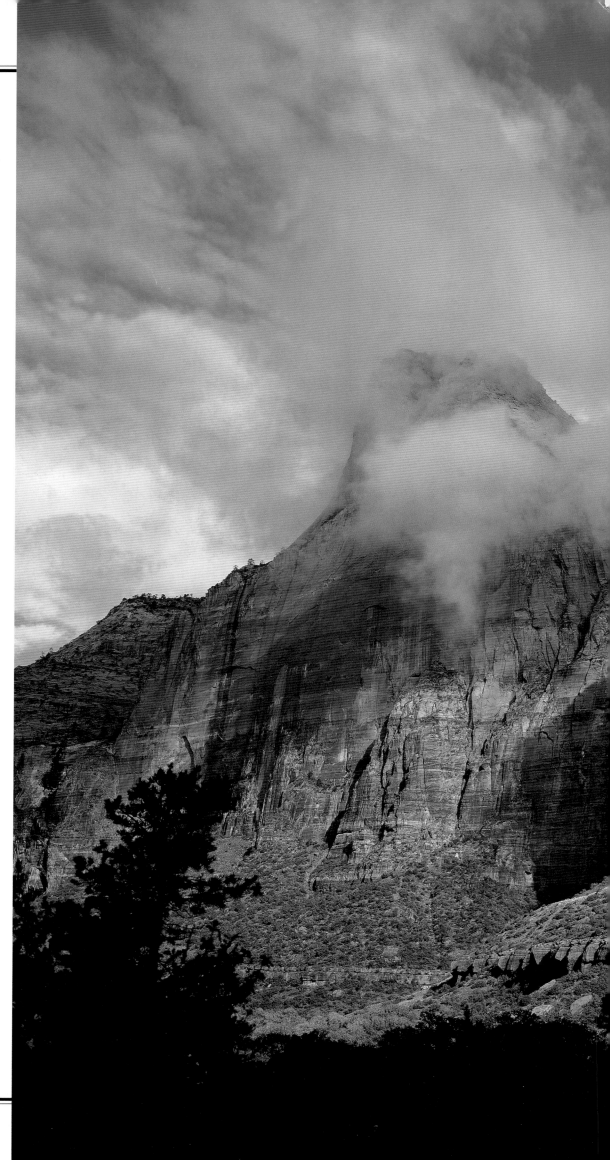

ACKNOWLEDGMENTS:

Special thanks to Zion National Park Superinten-
dent Don Falvey, Chief of Interpretation Denny
Davies, and Tom Haraden, Lyman Hafen of Zion
Natural History Association, and especially to all
the talented photographers who made their
imagery available for use in this book. —JDN

PRODUCTION CREDITS:

Publisher: Jeff D. Nicholas
Author: Nicky Leach
Editor: Cindy Bohn
Illustrations: Darlece Cleveland
Printing Coordination: Sung In Printing America

Printed in the Republic of South Korea.
First printing, Spring 2000.

SIERRA PRESS

4988 Gold Leaf Drive
Mariposa, CA 95338
(209) 966-5071, 966-5073 (Fax)
e-mail: siepress@yosemite.net

VISIT OUR WEBSITE AT:
www.nationalparksusa.com

SIERRA PRESS
MARIPOSA, CA

OPPOSITE:
Low clouds in Court of the Patriarchs, early
morning. PHOTO © DICK DIETRICH